BURSLEM

THROUGH TIME

Mervyn Edwards

Mervyn Edwards

AMBERLEY PUBLISHING

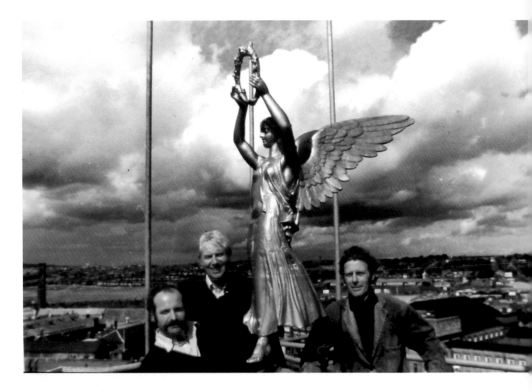

Meeting up with Civic Victory, 1983
Burslem's Old Town Hall is a mighty edifice erected in 1857. It is surmounted by the figure rightly called Civic Victory, but better known by the fictional name that Hanley-born author Arnold Bennett gave to it: the Golden Angel. In 1858, the figure fell to the ground during a thunderstorm. She was renovated in 1998 and could briefly be seen on display in the Potteries Museum in Hanley. The Old Town Hall looked decidedly odd without its talisman, but the figure was restored to its rightful position on 12 October 2001. The cost of the renovation – £5,000 – was met by the Heath family of Burslem, who ran three companies in the town.

First published 2012

Amberley Publishing
The Hill, Stroud
Gloucestershire, GL5 4EP

www.amberley-books.com

Copyright © Mervyn Edwards, 2012

The right of Mervyn Edwards to be identified as the Author of this work has been asserted in accordance with the Copyrights, Designs and Patents Act 1988.

ISBN 978 1 4456 0804 4

British Library Cataloguing in Publication Data. A catalogue record for this book is available from the British Library.

Typeset in 9.5pt on 12pt Celeste.
Typesetting by Amberley Publishing.
Printed in the UK.

Introduction

When Amberley Publishing asked me to produce this book, my first thought was, 'Why not? I've been planning it since 1989!'

It was in that year that I began recording history with a purpose. So the first photographic project I set myself was to take pictures of every public house in the Burslem area. I had always had a fervid interest in pubs and was rarely without a camera when I was younger. This gave me the chance to record social history – the events and celebrations staged by pubs, and the quirky behaviour of their customers.

The importance of people in photographs is rarely appreciated until the pictures we take have assumed the dignity of age. Only then can we chuckle over changing fashions, lament the disappearance of pub games like shove ha'penny and – let's be honest – look aghast at the pall of fag-smoke that hung like a blanket over the patrons of the cosy snugs.

Of course, he who records social history becomes part of it himself. In my youth, I spent many happy hours in the Duke William, eavesdropping on the conversations of the artist and author Arthur Berry. Bernard Frain was a dear old friend who was just as much a character as Arthur. Just when the ale was really beginning to flow and the laughter was threatening to pop the buttons on your shirt, Bernard would declare, 'Right, I'm off,' and be halfway down the road faster than you could flip a beer-mat.

Other institutions in the town have their charm, including the dignified Old Town Hall, the Georgian Big House and St John's church, hiding diffidently beneath the ridge on which Burslem came to be built. However, nothing lasts forever. Within recent years, the Burslem Suburban Club, the cemetery chapel, countless pubs and most of Middleport have all been demolished.

So on the face of it, there is plenty of material for a then-and-now style book on Burslem. The formula is, after all, tried and tested. However, in this book I hope to bring some less well-known facts to

the forefront: You don't have to be a member of Burslem History Club to know that the Wedgwood Memorial Institute was opened in 1869 and that Josiah Wedgwood and his fellow canal promoters met at the Leopard in 1765. However, you may not know that in 1866, Mr James was fined for allowing prostitutes to assemble in his beerhouse called, appropriately enough, the Why Not; or that a captured German gun was displayed in Burslem Park in 1919; or that Burslem fire station of 1956 was built on a concrete raft as a measure against subsidence.

Burslem may have its critics, but it is now re-inventing itself as the Creative Quarter of the Potteries. This book puts the spotlight on some of the people and places that have featured on its journey.

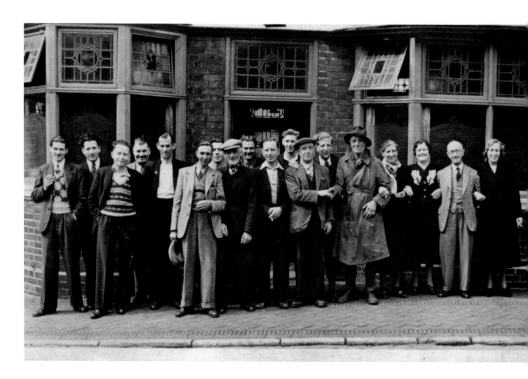

Foaming Quart, Greenhead Street, 1950s
Left to right: Harry Williams, Bill Findler, Jack Colclough, -?-, George Wood, Abe Brian, -?-, Jack Finney in the large cap, -?-, Jack Findler in the open-neck shirt, -?-, -?-, -?-, -?-, -?-, Emmy Cousins in the black coat, a barmaid, Billy Simcoe the landlord and Emily Seaton.

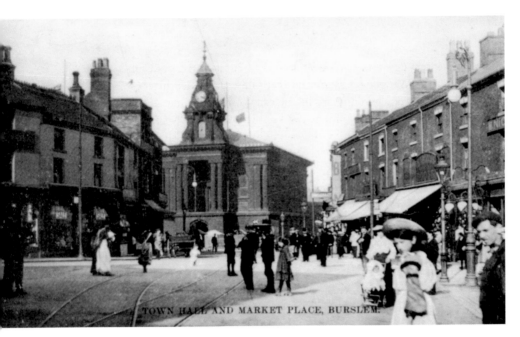

TOWN HALL AND MARKET PLACE, BURSLEM.

Market Place, Early Twentieth Century and 2010

Our street scenes section begins with these views of Market Place, and a majestic civic building that was a long time in coming. It was first mooted as early as 1846 when the trustees of the Burslem market began to discuss the advisability of building a new town hall. However, by October, a newspaper correspondent saw fit to criticise the market trustees for the lack of progress with the project – especially as new public buildings had been erected in Longton, Stoke and Hanley. Burslem could only look on with envy at the imperious new edifice that was being established at Stoke. Discussions rumbled on for years, but the project was given fresh impetus by the establishment of the Burslem Local Board of Health in 1850. The Town Hall eventually opened in 1857, and the statue of manufacturer Henry Doulton was placed in front of it in 1991.

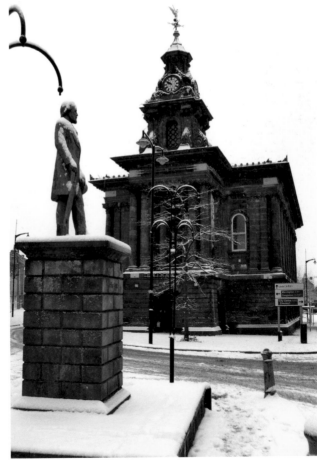

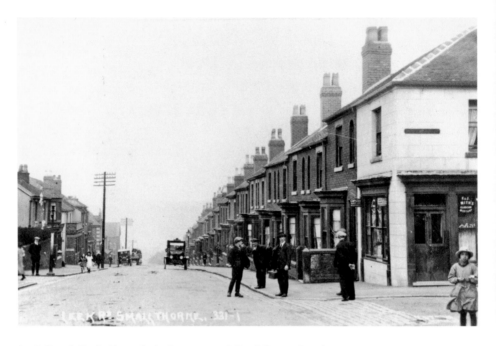

Leek Road, Early Twentieth Century and Ford Green Road, 2007

Here is Leek Road – now Ford Green Road. The children on the left are passing the Forresters Arms. Thousands of free meals were handed out to local families in the pub's back yard during the 1921 miners' strike. Louise Tunnicliffe, the licensee's wife, ladled out soup from a cast-iron washing boiler. Roger Bean's footwear shop opened in 1971, moving into the premises seen in the picture in 1980. It closed in 2008, its manager at the time being Mandy Bogucki.

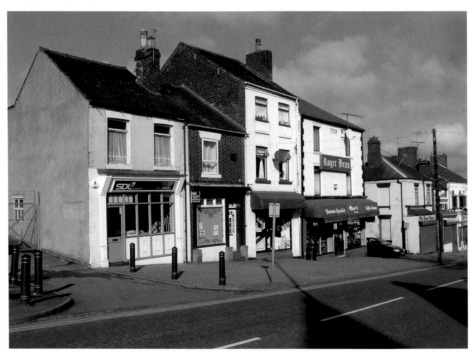

Topside of Burslem, Early 1920s and Early 1960s

High Lane seen from Smallthorne in the early 1920s. The children are Doreen, John and Edwin Pankhurst. The semi-rural nature of this pocket of Burslem and the nearby Smallthorne area was noted by author Arthur Berry, who wrote that in the 1930s Smallthorne 'still had a strong whiff of the country about it'. In the lower photograph, we see Jean Nevitt, Sheila Bradley, Ivan Baskeyfield and Norma Nevitt outside no. 57 Bank Hall Road, which runs parallel with High Lane.

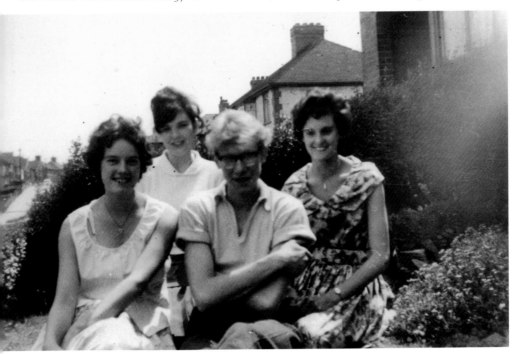

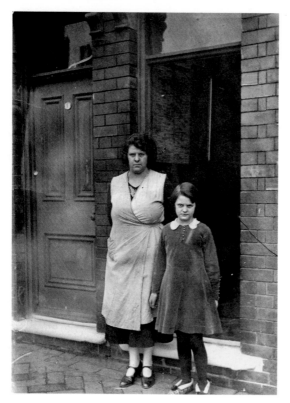

Bycars Road, *c.* 1932 and 2010
The top picture shows Daisy Shelley and her daughter Irene. There are early references to the Bycars Colliery, referred to as the Bykers Colliery on Thomas Hargreaves' map of 1832. We know from pottery manufacturer Enoch Wood's scrapbook that brass fittings were stolen in 1805 from the steam engines at the Sneyd and Bycars Collieries. We also know that a large, subscription warm bath was opened at the Bycars Colliery in 1816. It must qualify as one of the first pithead baths in the country and was 'circular, and sufficiently large for the exercise of swimming'. Its interior boasted decoration in the form of landscapes and sea views, painted by an eminent artist. After a few years, it fell into disuse.

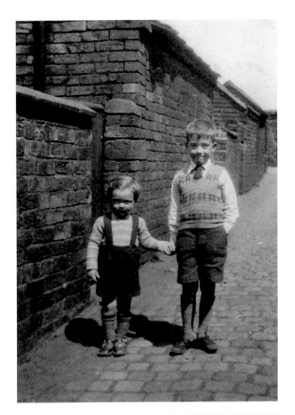

Enoch Street Back Entry *c.* 1954 and Enoch Street/Pleasant Street 2012
Two boys pose in the back entries off Pleasant Street, with Desmond Wilson on the right. Pleasant Street appears on the Thomas Hargreaves map of 1832, one of the first detailed maps we have of the area. A glance at the 1900 ordnance survey map shows the numerous terraced houses in the street and in nearby Enoch Street, Croft Street, Velvet Street and King Street. Much redevelopment has taken place since, and the modern photograph shows new housing and open spaces.

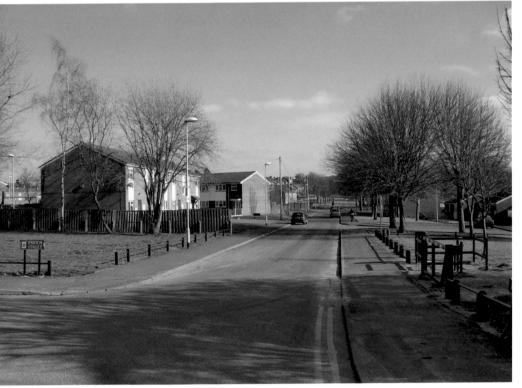

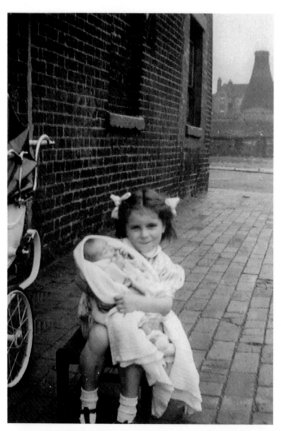

Enoch Street *c.* 1949 and 2012

'Enoch Street, Pleasant Street' is mentioned in a list of streets in Burslem in *White's Directory* of 1851. The street was not always healthy due to the insalubrious state of the churchyard. A local inhabitant wrote to the *Staffordshire Mercury* newspaper in 1847 that some of the vaults in the poorly-drained churchyard often filled with water, and that he had seen coffins literally floating. Mary Fowlds is holding the baby in the old photographs, which date from around 1949.

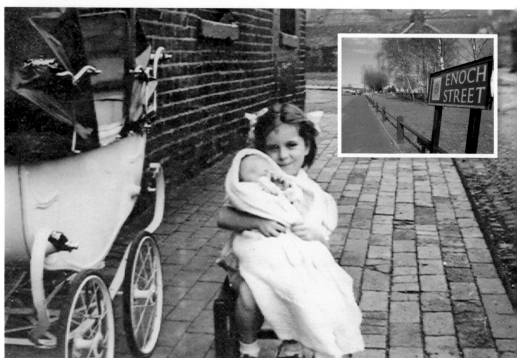

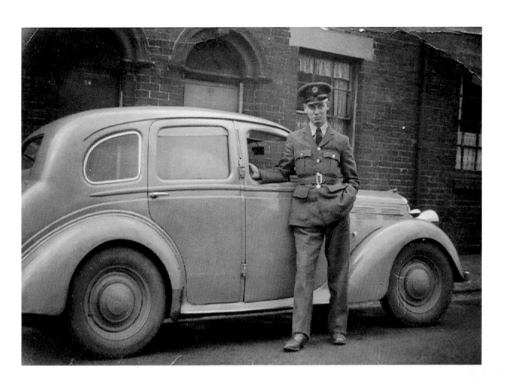

Enoch Street 1955 and 2012

Albert Bonehill stands outside no. 24 Enoch Street. The street recalls Enoch Wood (1759–1840), a manufacturer, civic grandee and churchwarden of St John's. The calcining ovens in the new photograph are a reminder of the industrial town that Wood was influential in developing.

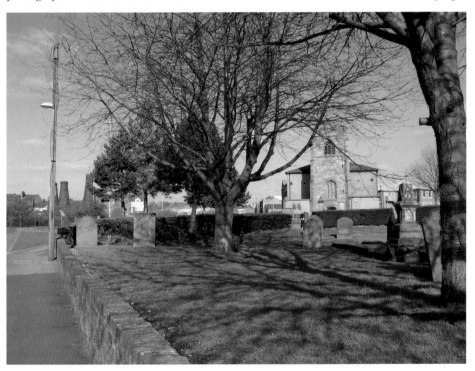

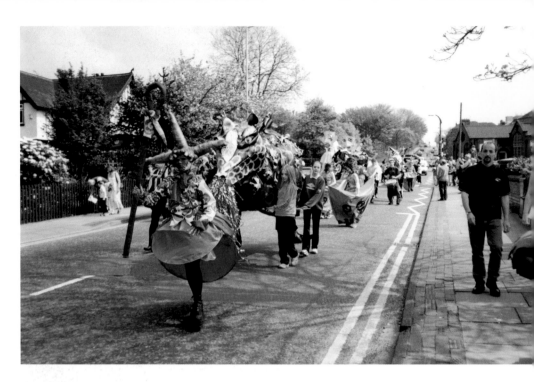

Parade Down Moorland Road, 1999 and Moorland Road Snack Bar, 1994
John Ward wrote, in around 1840, that Moorland Road was constructed in 1820, much of the work being done by unemployed potters and miners. Certainly by the 1860s there was a Colliers Arms beerhouse in Moorland Road. The main entrance to Burslem Park in the upper photograph shows a Burslem Festival procession from the park. Moorland Road Snack Bar was once a popular venue for weddings and parties but is long-demolished.

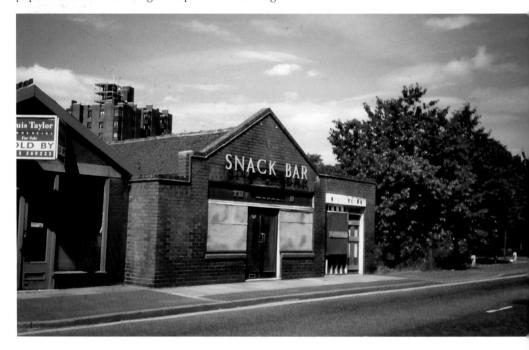

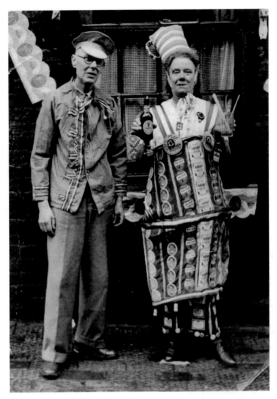

Globe Street, Dale Hall, 1953 and 2012
The occasion (top) is the Queen's Coronation in 1953, celebrated by two colourful characters. The lady is Gertrude Tudor. Globe Street has changed radically since, with few of the older terraced houses remaining. The low wall in the distance encompassed a massive Anglican church prior to its demolition in April, 1974. St Paul's was consecrated in 1831 and could accommodate around 2,000 worshippers. St Paul's Junior School stood adjacent. The square tower of the Roman Catholic church of St Joseph, in Hall Street, Burslem, can be seen in the background.

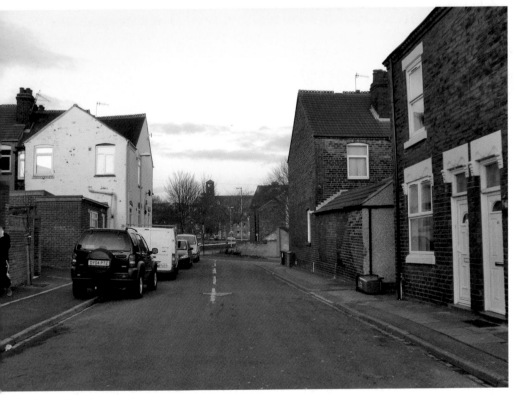

Longbridge Hayes 1988 and 1947

An *Evening Sentinel* article of 1998 described Longbridge Hayes as 'the village that simply vanished'. It was bulldozed in order to make room for new industry. The last remaining resident had been Terry Scott, a builder, who had lived in Longbridge Hayes all his life. The photograph (bottom) shows Mayor Knowles and the Mayoress of Newcastle at a Christmas party for the children at the Longbridge Hayes British Legion, 1947.

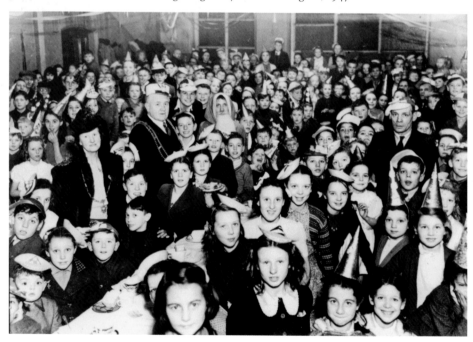

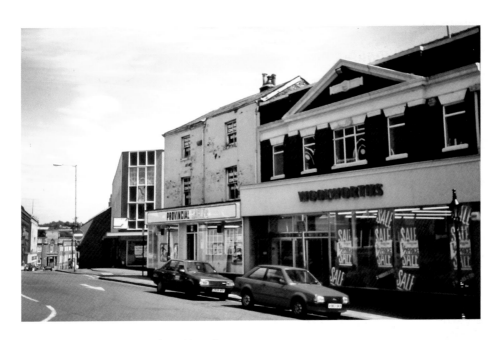

F. W. Woolworth & Co. Ltd, 1966 and 1994

The Woolworths store in St Johns Square opened in September, 1929, its first manager being L. H. Hewitt. It is worth noting that the Burslem 'Woolies' stocked a range of locally manufactured china and pottery items. The 1966 photograph (courtesy of Paul Seaton and Woolworths PLC) was taken just after modernisation. The store is much-missed in Burslem today.

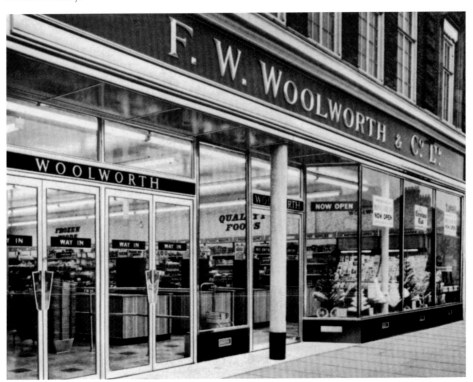

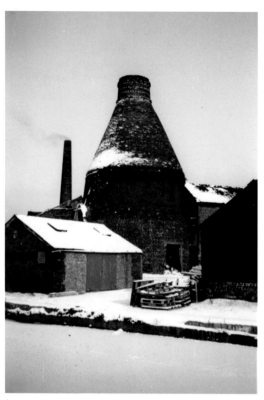

Trent & Mersey Canal, Longport, 1991 and 2007

Industry flourished in Burslem, known as the Mother Town of the Potteries and an early centre for pottery manufacture. Master potters were given a huge boost with the opening of the 93-mile Trent & Mersey Canal in 1777. Here it is, snaking through Longport. One observer, J. Aiken, wrote in 1795: 'Long Port, situated between Burslem and Newcastle, in a valley, has some good buildings in it, and several considerable manufactories; but its situation thereby is rendered disagreeable, if not unwholesome, by the smoke hanging upon it longer than if it was on higher ground.' The canal engineer was James Brindley. His younger brother John built the first two pottery manufactories in Longport, following the opening of the new waterway. Price and Kensington became a famous name in Longport, and the photogenic bottle oven pictured has long been a magnet for artists.

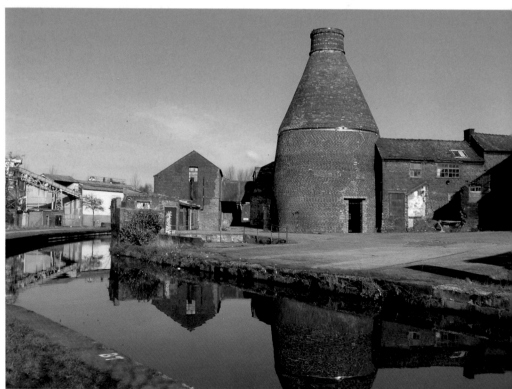

Fred Bennett and Inset 1972, and a Royal Doulton Demonstrator, 1996

In 1882, the Lambeth potter Henry Doulton acquired the modest factory of Pinder, Bourne and Company in Burslem. He was cold-shouldered by the Staffordshire claymen, later writing, 'In their view, we Southerners know little about God and nothing at all about potting.' However, the company's progress was rapid, and in 1901 King Edward VII granted it a royal warrant and the specific right to call itself 'Royal'. Fred Bennett was a stalwart, retiring in 1972 after forty-six years of service.

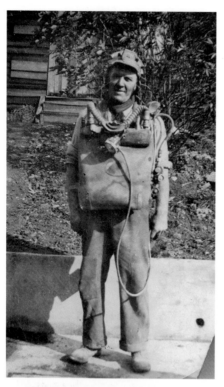

William Belcher, 1930s and Sneyd Pit Disaster Artwork, 2010

William Belcher (1890–1961) was one of the mines rescue team at Sneyd Colliery at the time of the 1942 pit disaster in which fifty-seven men lost their lives. We know from his surviving daughter, Pat Foster, that he was a regular at the Greyhound pub in Smallthorne and the Smallthorne Victory Club. However, he never drank Parker's beer – which was famous in Burslem – preferring to imbibe Alsopp's and Bass. He had a severe leg injury for many years, but refused to have it amputated, also suffering from pneumoconiosis. He died poor, at the age of seventy. The artwork depicting mourners in 1942 was displayed as part of the Ceramica exhibition at the Old Town Hall.

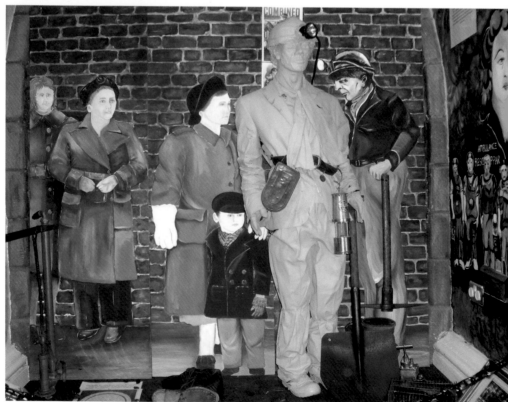

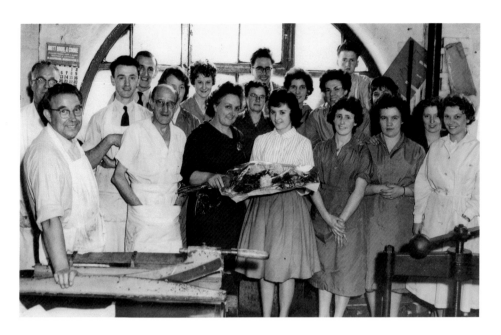

Warwick Savage Printing Works 1960 and 2012

Warwick Savage Ltd, according to company records, began in 1787 as a stationer's shop at 28 Market Place, incorporating printing equipment to the rear. It was then owned by Mr Baker, but following several changes of ownership the company was acquired by Mr Warwick Savage around 1865. His two sons, Warwick and George, took over the business in 1891 and moved into new purpose-built premises at Wedgwood Place. The company became known for quality printing. The building is now derelict.

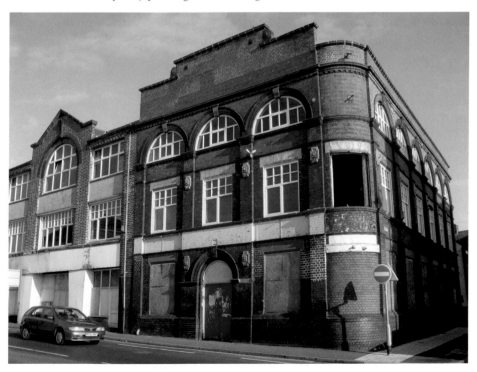

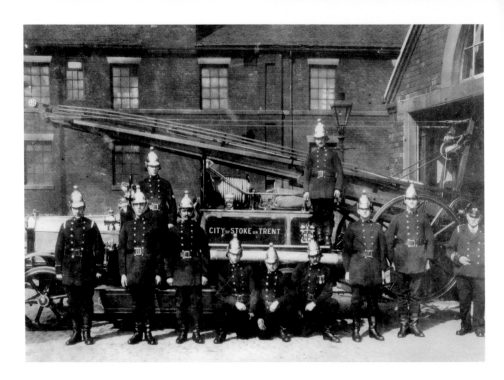

Burslem Fire Station, *c.* 1926 and 2010

During the Burslem Wakes of 1844, a portable theatre was discovered to be on fire. The town fire engine was summoned, but found to be 'so much out of repair as to be quite useless'. Subsequently, a new fire engine called *Niagara* was ordered, necessitating a sixpenny levy on the local rates. Our photographs show the old fire station on the corner of Baddeley Street and Scotia Road, and the fire station that opened in Hamil Road in 1956.

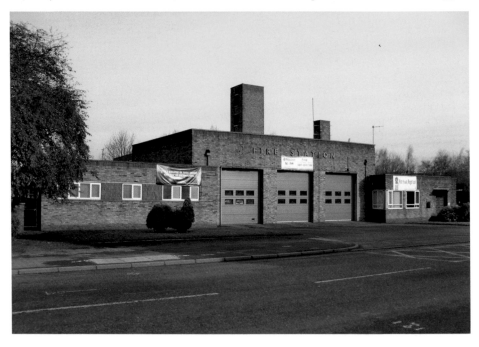

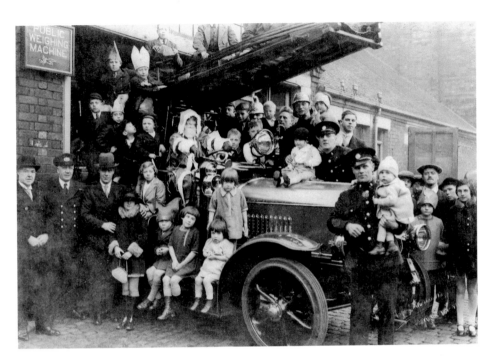

Burslem Fire Station and Santa Claus, *c.* 1928 and New Station, Hamil Road, 2012
Santa, played by Charles Allen Shelley, is at the wheel of the engine at the Baddeley Street fire station and pictured at a firemen's children's party at the station, around 1928. His daughter Irene is one of the children sitting on the vehicle. A brand new fire station was opened in Hamil Road in 2011 (pictured). Its longest-serving firefighter at the time of the opening was Julian Foster, aged fifty-two, who had been in the service for twenty-seven years.

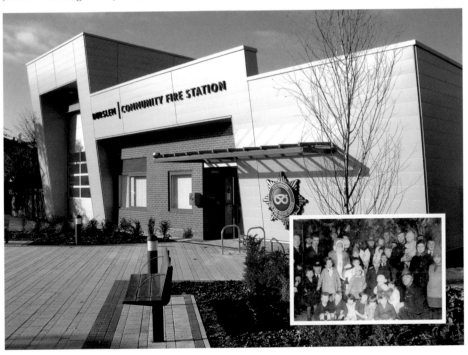

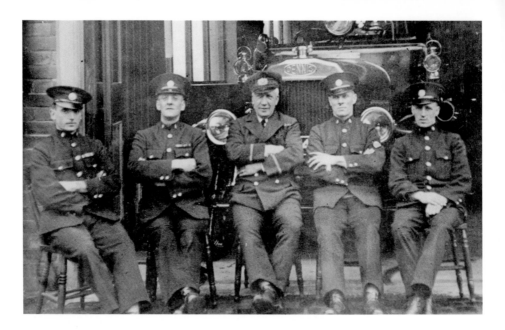

Burslem Fire Station, *c.* 1930 and New Station's New Gate, 2012
Charles Allen Shelley is on the far left of the above photograph. He was the grandfather of Elizabeth Fowlds, whose family recall that Charles lived near the fire station and went to sleep with his trousers and boots right beside his bed, in readiness for an emergency call. The ornamental gate is placed to the left of the new station and was designed by Aaron Turnock, Jack Hough, Rebecca Chawner, Harriet Ford and Emily Simpson from the Haywood Engineering College.

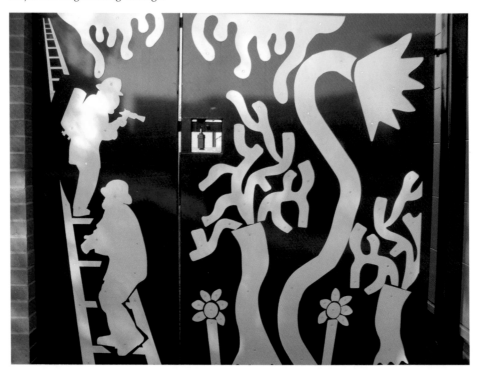

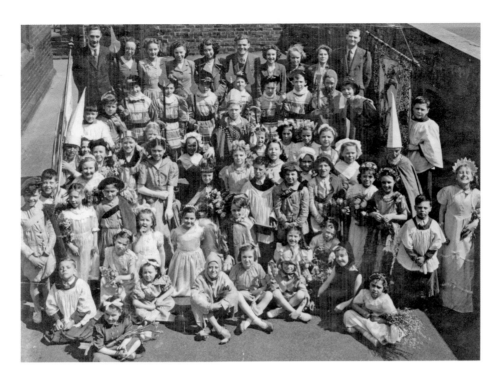

Sneyd C of E School Pageant, *c*. 1947 and Sneyd Pit Memorial, 2012

Our section on education begins with Sneyd C of E School, opened as Sneyd National Schools in 1867. It was built on Nile Street, between Wellington Street (later Auckland Street) and Adelaide Street. It was situated a short distance from Sneyd church (Holy Trinity), opened in 1852. The pit memorial recalls the fifty-seven men and boys who died in the Sneyd Colliery disaster of 1942.

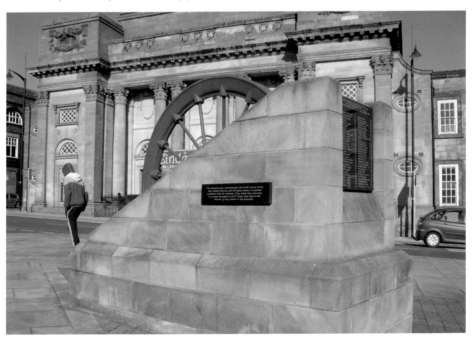

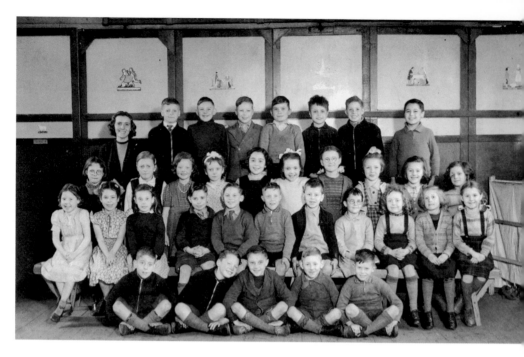

Sneyd C of E School, 1950 or 1951 and Present Building, 2012
The class teacher in this school group is Miss Charles. In the 1950s children from the school used to collect wild plants from the area around Sneyd Colliery for the pupils' nature table. There was a corner shop near the school – run by a Mrs Wright – that sold groceries and sweets. Pupils often played cricket and football in Cobridge Park. The school building is now used as business premises.

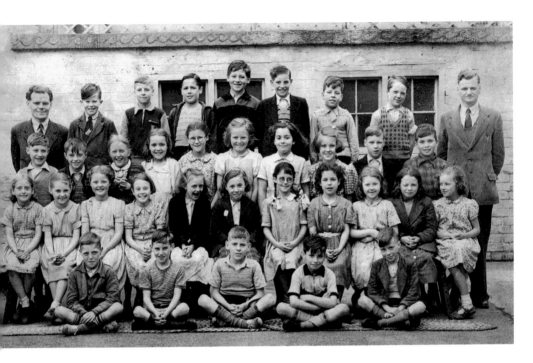

Sneyd C of E School, 1951 or 1952 and Present Building, 2012
School pupils pose for a photograph in the early 1950s. The class teacher on the left is Mr Charles and the one on the right is Mr Hudson. Holy Trinity church in Nile Street was finally demolished in 1959, subsidence having rendered it unsafe. The congregation had been dwindling on account of the demolition of many old terraced houses in the vicinity.

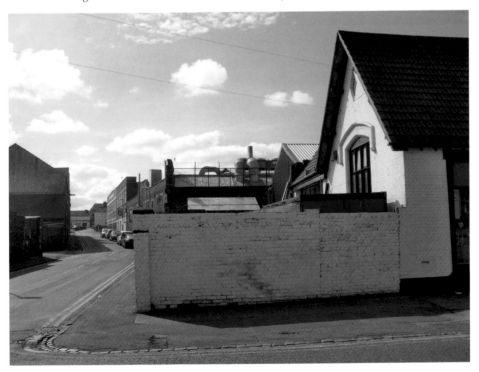

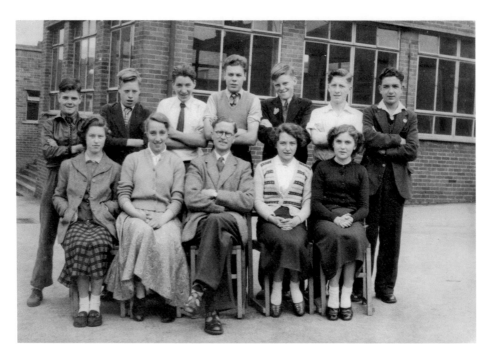

Park Road Secondary School, 1954 and Moorpark Junior School, 2012
Mr Mountford is in the centre of the front row. Other teachers recalled by former pupils of Park Road School are Mr Yeomans (Science), Mr Cliff (Music) and Mr Lake (Art). The latter was heavily involved in Wings for Victory Week during the Second World War and also embraced Dig for Victory. Pupils tended allotments in Hamil Road.

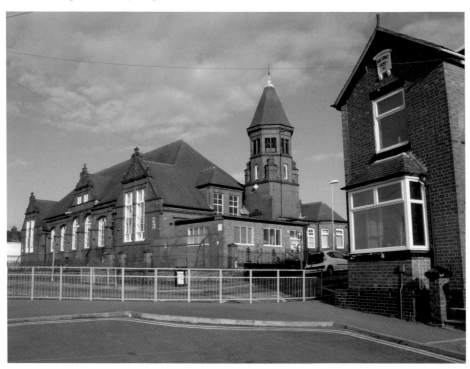

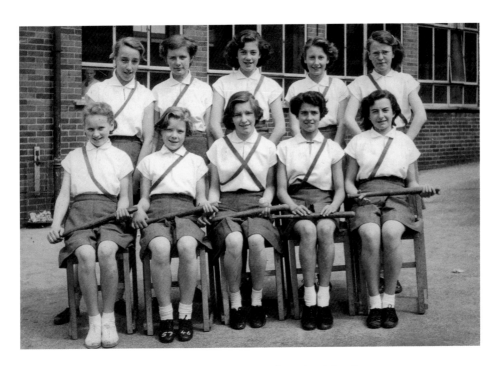

Park Road Secondary School, 1954 and Moorpark Junior School, 2012
Here is the school rounders team. The woodwork classroom is to the rear, a former woodwork teacher being Mr Grant. There were separate playgrounds for boys and girls at the school, and the genders were also kept apart for PE, which took place in the assembly hall where there were mats and a wooden games horse.

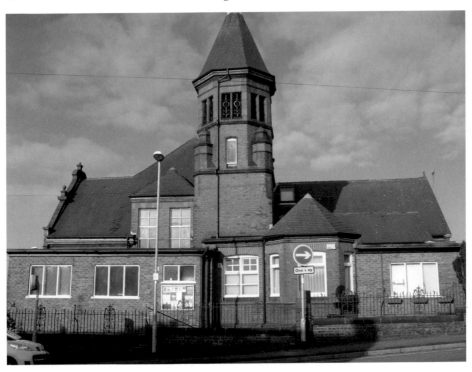

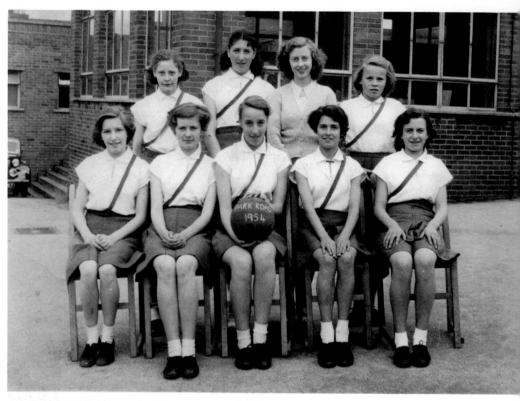

Park Road Secondary School 1954 and Moorpark Junior School, 2012 Miss Moss stands third from the left on the back row. Sport was important at the school. Old pupils recall that the annual sports day was held at Norton cricket ground at Smallthorne. Football was played near the foot of Hamil Road, close to the present fire station. The school faces Burslem Park.

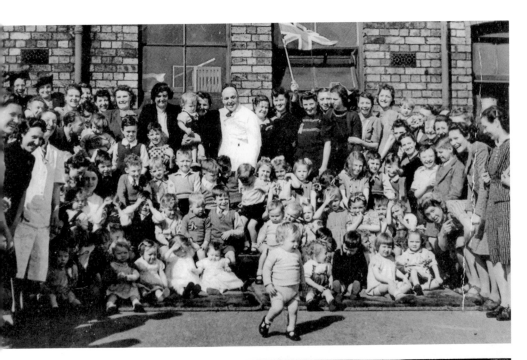

St John's School, *c.* 1945 and St John's Church Bellringers Tablet, 2012

The contribution of St John's church to the wider community of Burslem is illustrated in the above school photograph and in the tablet commemorating the bell-ringers of yore. The people above are celebrating the end of the Second World War. The *Staffordshire Knot* newspaper referred in 1882 to the 'large mural tablet on the front of the tower' honouring the memory of several bellringers. It also referred to the ringing room and its large board of printed rules for the government of the ringers. Scholars and musicians often worked together for a good cause. In 1887, St John's was planning to purchase a new American organ. A fundraising entertainments evening was held in the parish schoolroom, supported by vocalists and handbellringers.

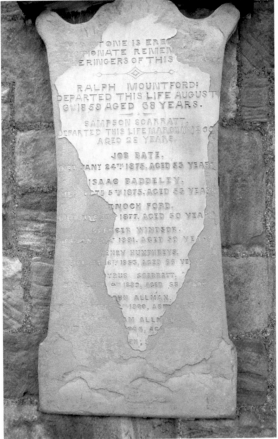

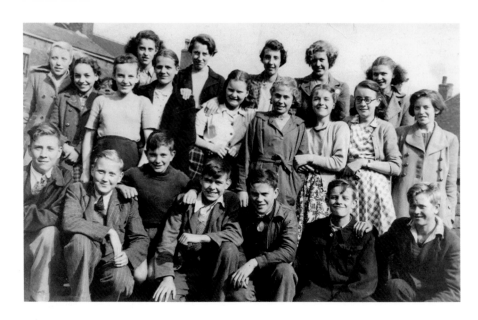

St John's Senior School, 1950 and Members of the Potteries Pub Preservation Group, 2009

St John's senior school, showing Mr Tavernor's class, 1950. Back row: Jean Brooks, Marion Hulstone, Sylvia Dunning, Betty Harper, Margaret Wood. Middle row: Brenda Davies, Lillian Smith, Rhoda Boulton, Margaret Aaron, Pearl Windsor, Ethel Smith, Bernice Bourne, Doris Owen, Irene Scarratt. Front row: Graham Parry, Nicholas ?, Maurice Jarvis, Harold Harper, Dennis Sutton, Leonard Scarlett, Kenneth Oakes. Harold Harper later became Chairman of PPPG, some of whose members sit outside the Ceramica Shop (below). Harold is at the rear, second left.

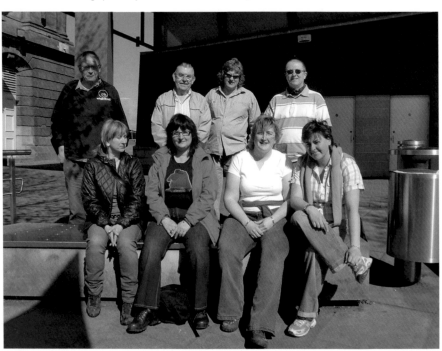

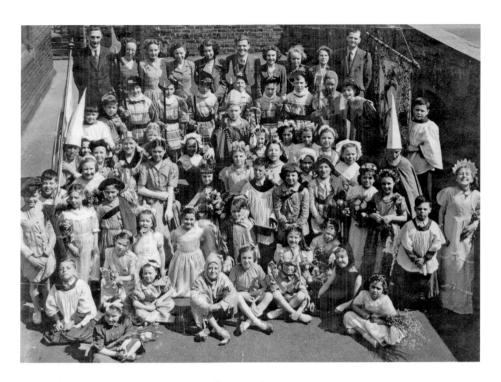

St John's Senior School, c. 1951 and the Creative Innovation Centre, 2012
The children above are pictured in the extended playground that backed on to Pitt Street
West. Football and cricket were often played at the Grange, nearby, but in later times, the
pupils used Trubshaw Cross playing fields. Children were also led up to the swimming
baths in Moorland Road. The Creative Innovation Centre in Cross Hill now occupies the
site of the old school.

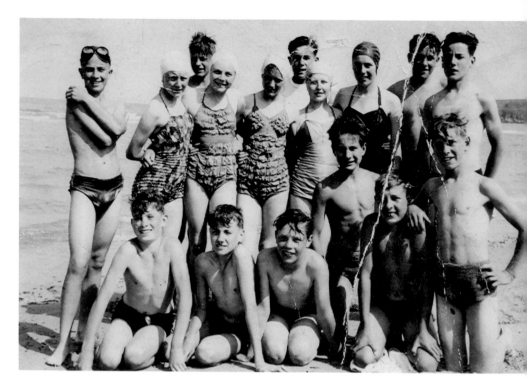

St John's School Trip to Anglesey, Mid-1950s and St John's Church, 2012
This St John's school trip to Anglesey shows several happy children, including Wilf Deakin (far left), George Chesters (far right, rear) and Alan Brookes (far right, front). As a community church, St John's continues to attract all ages.

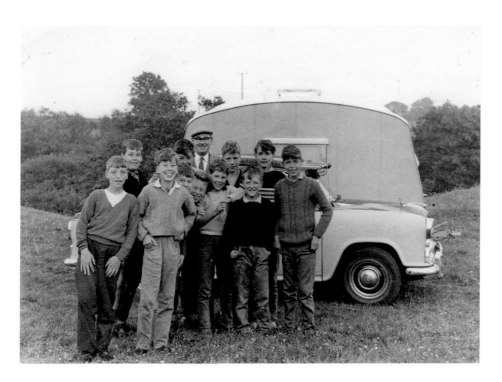

St John's School Trip to Anglesey, *c.* 1960 and St John's Church, 2012
The adult in the above picture is teacher Mr Tavernor, who slept in his caravan, which is pictured here behind his car. The boy in the striped jumper on the back row is Terry Cartlidge. His friend, Peter Hemmings, stands in front of him.

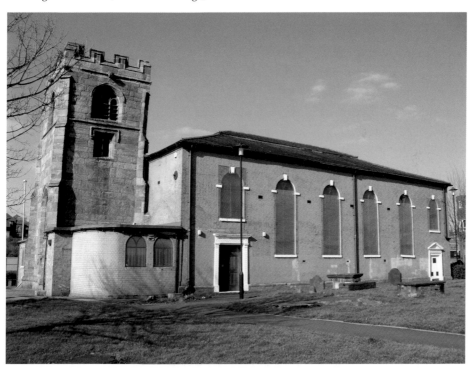

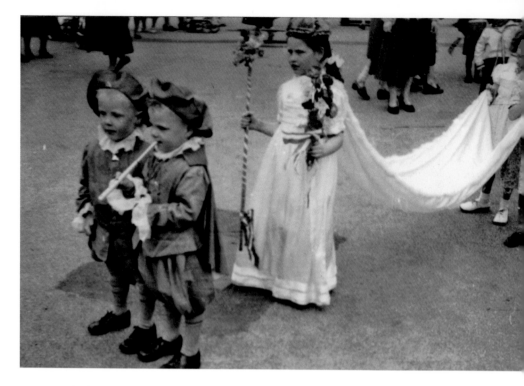

St John's Infant School, 1953 and St John's and Churchyard, 1994
The Coronation Queen appears in June, 1953, at St John's infant school. It stood near to the
table tomb of Margaret 'Molly' Leigh, seen here. Legend paints her as the Witch of Burslem.
School children would dance around her tomb, inviting her to appear. However, far from
being a modest milkmaid with supernatural powers, Margaret was a woman of wealth and
status who had the ill fortune to die at the age of twenty-four in 1748.

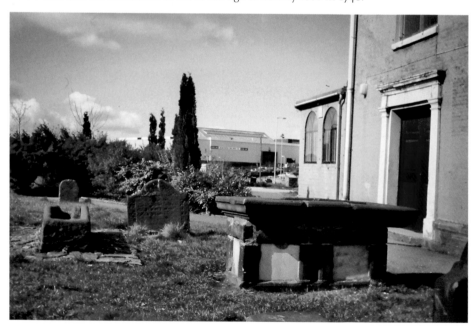

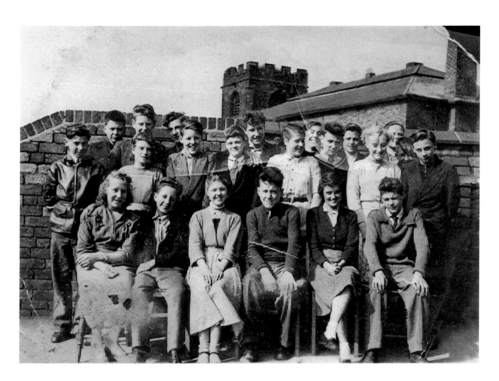

St John's School, Mid-1950s and Lydia Palmer, 2011

The square tower of St John's is noticeably more sullied by industrial pollution than it looks today. The church retains a strong connection with the young, running a successful toddlers group. Lydia Palmer has been a leading light over the years, and our photograph shows Lydia saying a few words at a Burslem History Club meeting at the Leopard.

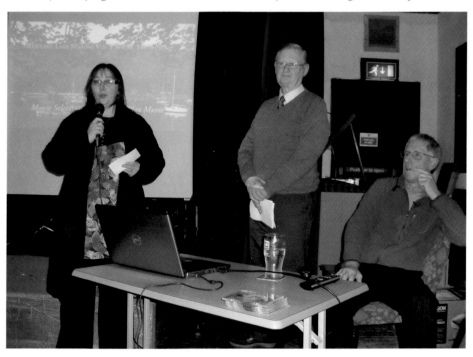

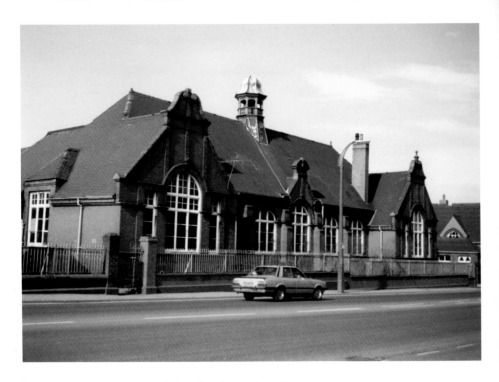

Longport Schools, 1991 and Brindley Court Care Home

The Longport Schools are shown during demolition in 1991, with the old playground and shelter to the rear. The site is now occupied by the Brindley Court Care Home. Its name recalls James Brindley (1716–1772) who designed the Trent & Mersey Canal which runs through Longport.

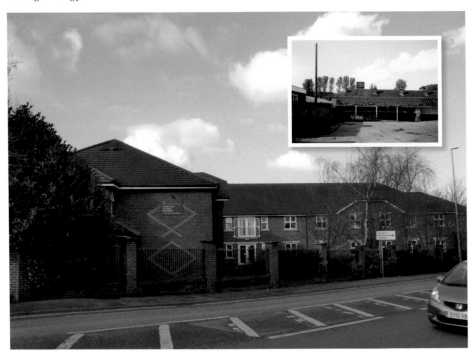

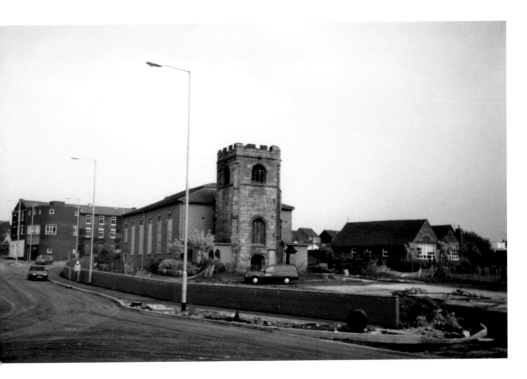

St John's Church, 1991 and 2012

Churches and chapels in Burslem were plentiful. The upper photograph shows St John's church and the construction of the Burslem bypass in 1991. The oldest part of the present church is the stone tower, dating from around 1536, inside of which is a spiral staircase leading to the belfry. The tower is Perpendicular in style and not dissimilar to church towers at All Saints, Madeley and St Mary, Castlechurch, Stafford.

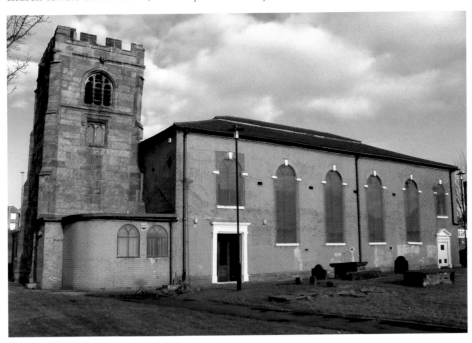

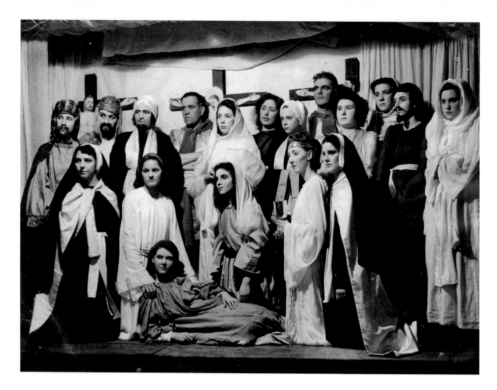

Cobridge Dramatic Society and Christ Church, Cobridge, 1995
Maggie Leigh was the originator of the Cobridge Dramatic Society, which gave concerts in such places as hospitals. She also ran youth groups on Saturday nights, with children being invited back to her home after church on Sunday evenings. The above photograph shows a passion play for Easter, Passover in Jerusalem, dated April, 1944. It was held in the Cobridge Christ Church C of E School. The gentleman with his arms folded at the back is Brynmore Rees.

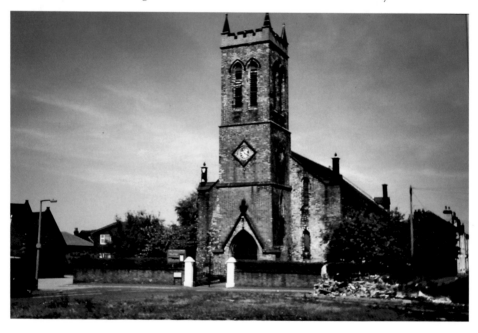

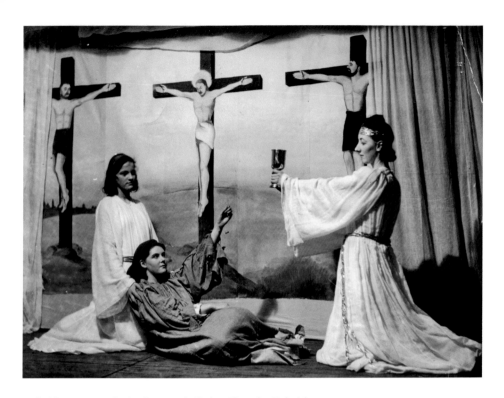

Cobridge Dramatic Society and Christ Church, Cobridge, 2012
Another photograph of a passion play at Easter. One of the figures in the foreground offers
a chalice. The yellow-brick Christ Church has weathered well since its erection in 1839–41.
It was enlarged in 1845/46. Designed to accommodate 550 persons, it had a vicarage and
school to its left.

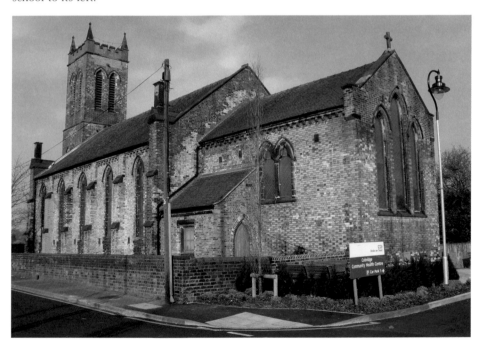

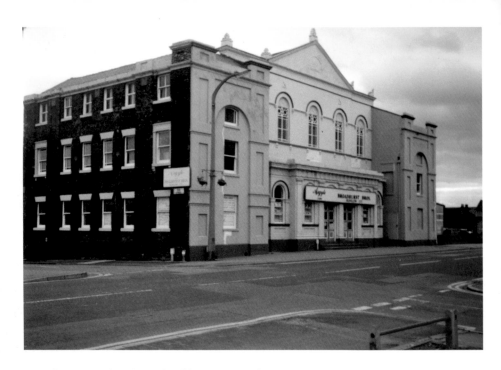

Broadhurst Brothers' Argyle China, 1990 and 1991

A timespan of only ten months separates our two photographs of this Waterloo Road premises. However, it is what happened in the meantime that makes these striking 'before' and 'after' pictures. The off-white façade of the former Bethel Methodist chapel was repainted in a vibrant pink colour in July, 1991. Stoke-on-Trent City Council found the new colour 'excessively garish' and 'intrusive.' However, this was not the view of the Potteries Heritage Society, which backed the owners.

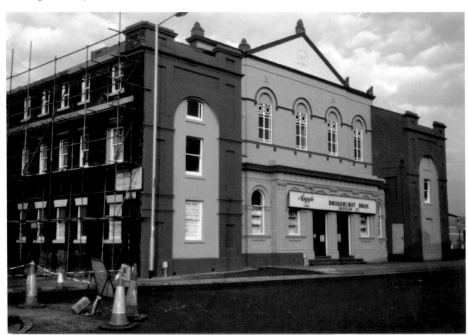

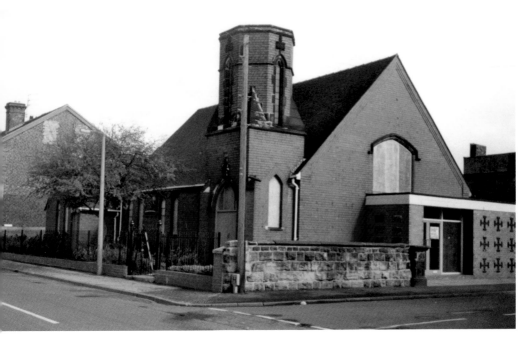

Middleport Methodist Memorial Church, 1991 and the Holy Catholic Church, 2011
This place of worship was built in Newport Lane in 1924 as a memorial to the Middleport men who perished in the First World War. A Roll of Honour listing their names was later placed inside the church. Labelled 'unviable', the church closed in 1999 but was re-opened shortly afterwards as the Holy Catholic church. It was demolished in July 2011.

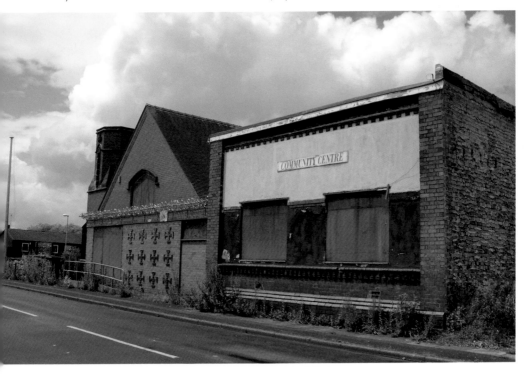

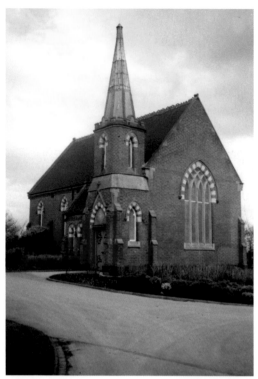

Burslem Cemetery Chapel, 1991 and During Demolition, 2010

Burslem Municipal Cemetery was consecrated in 1879, and its chapel completed by October, 1880. The 28 acres of grounds was intended for dual use as a recreation park, for it would not be until 1894 that the town's municipal park would open. The *Staffordshire Sentinel* recorded that it was much anticipated that the cemetery would be 'much patronised as a promenade.' In recent years, part of the chapel ceiling fell down, and the structure was eventually demolished.

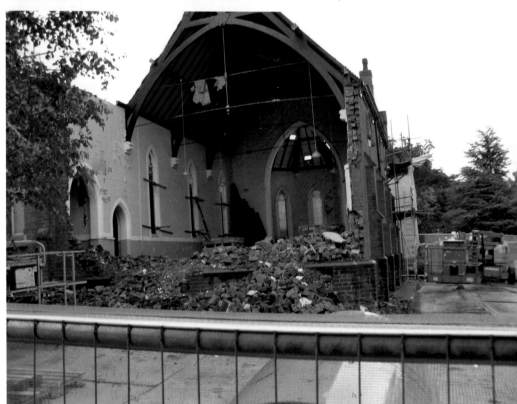

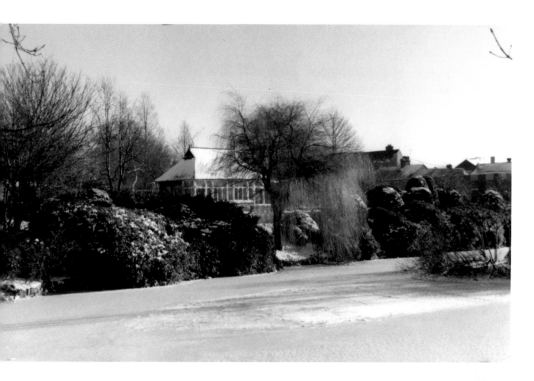

Burslem Park Aviary, 1980s and 1994

Let's take a stroll in the local parks. A tender of William Cooke amounting to £120 for the erection of the aviary in Burslem Park was accepted in September, 1900. The aviary housed unusual birds such as Australian grass parakeets, Virginian nightingales, and redpolls as well as a barn owl. In 1995, it was reported that the aviary had closed after more than half of the birds had been shot, stolen or released into the wild. Demolition followed.

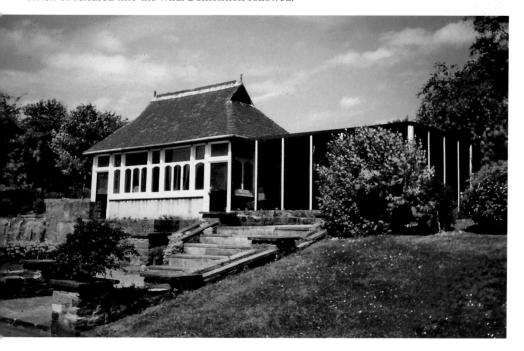

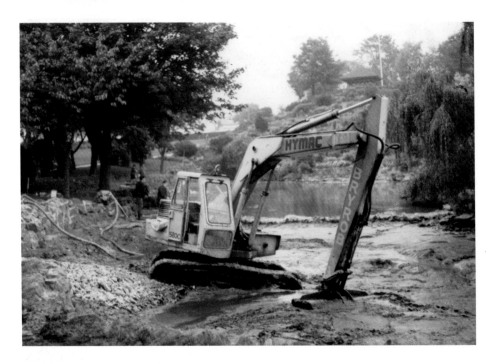

Burslem Park Lake, 1980s and 2012

The summerhouse – seen in both photographs – stands on top of an old pit mound and gives fine views of the park and its users. In *Anna of the Five Towns* (1902), Arnold Bennett wrote of the various social echelons who visited the park on Sundays, including the 'sedate elders of the borough who smiled grimly to see one another on Sunday afternoon in that undignified, idly curious throng.'

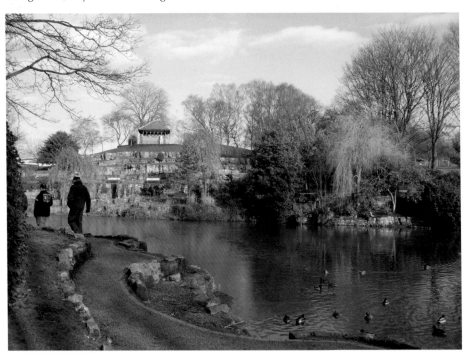

Burslem Park Greenhouse, 1980s and Pavilion, 1994
Flowers were a huge attraction in the park from its opening in 1894, but its centrepiece was the pavilion, built of brick and timber in the Elizabethan style by J. Allport, a local man. It originally consisted of a central hall with rooms to the right and left, which from the outset were planned as reading rooms for ladies and gentlemen. A large first-floor room was intended for recreational purposes, whilst refreshments were served in the entrance hall.

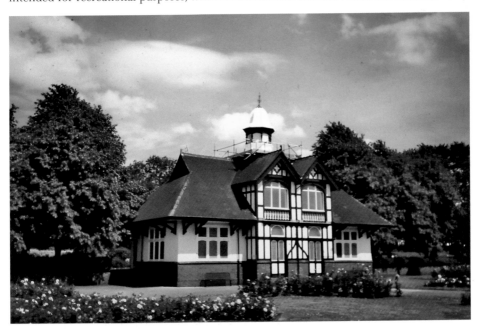

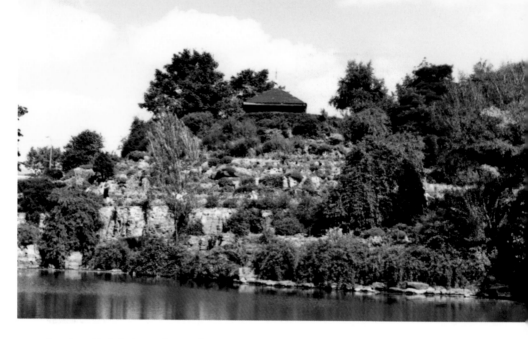

Burslem Park Lake, 1980s and 2012

The lake was supplied by a drain from the Sneyd Colliery and was initially well-stocked with fish. Unfortunately, many were eaten by cormorant and heron. Near to the lake was rockwork and cascades. Formerly, subsidence blighted the park on account of local mining operations. In 1921 all the water in the park lake was suddenly swallowed when an old pit shaft opened up.

Cobridge Park And Bowling Green, 1993 and 2011

Cobridge Pleasure Grounds were opened in 1911, costing in the region of £9,000. It incorporated a tennis court and bowling green. The proximity of local industry influenced early horticultural efforts in the park. The press reported: 'The ground is surrounded by, and stocked with, shrubs and saplings, varieties being selected which will thrive in smoky atmosphere ...'

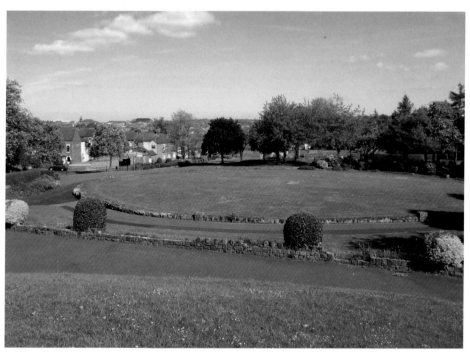

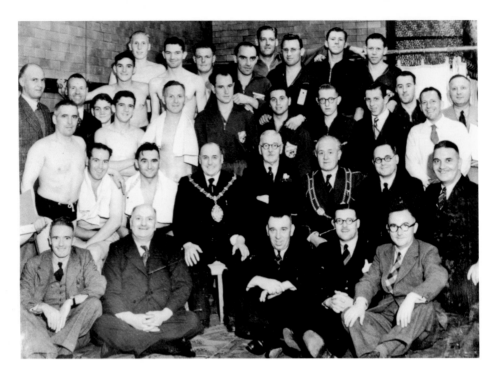

Burslem Swimming Baths and Mayor Knowles, c. 1948 and the Site Today
Sport and leisure in Burslem may have meant a trip to the swimming baths in Moorland
Road, opened in 1894. In later years, the swimming club often held dinners at the Leopard.
Our photograph shows W. A. Knowles, the Mayor of Newcastle-under-Lyme, on the second
row, third from the right. He is pictured with Dutch international swimmers.

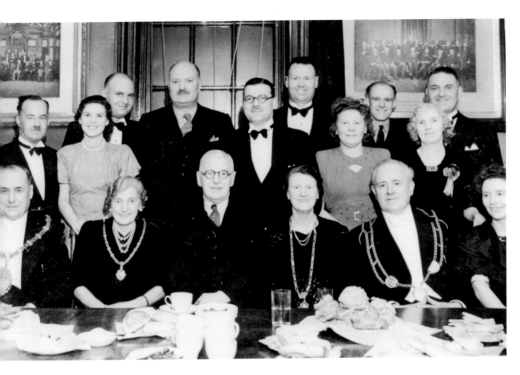

Burslem Swimming Club Dinner, *c.* 1948 and Dimensions, 2012
The top photograph shows Mayor Knowles, second from the right on the front row, at a
Burslem Swimming Club dinner. The baths in Moorland Road is long gone, but the opening
of Dimensions, overlooking Scotia Road, in 1993, re-introduced aqua leisure in Burslem.

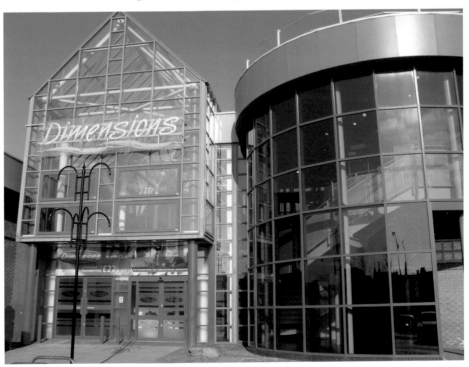

Derelict Cobridge Stadium, 1993 and Stadium Court Nursing Home, 2012
This pocket of Cobridge had a colourful sporting history. Port Vale football club had played on site from 1886 until 1913, while horse-racing was offered to the public in the 1920s. However, a greyhound racing track opened here in 1932, described as being 'in a class above those in all but the largest cities of the country'.

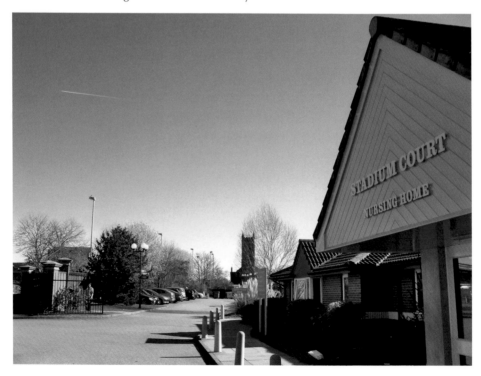

Cobridge Stadium Entrance, 1993 and Greyhound Way, 2012
Greyhound racing ended in November, 1990, with Chasewater Greyhounds moved its operation to Ellesmere Port. The old stadium lay derelict for some time afterwards. Much of the surrounding area has been redeveloped, but the modern road sign gives a clue as to the previous use of the site. Our photograph shows a family taking a breather from their shopping trip to Festival Park.

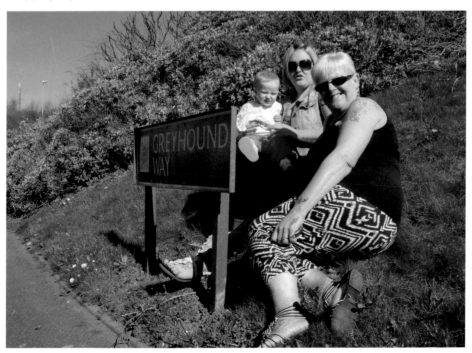

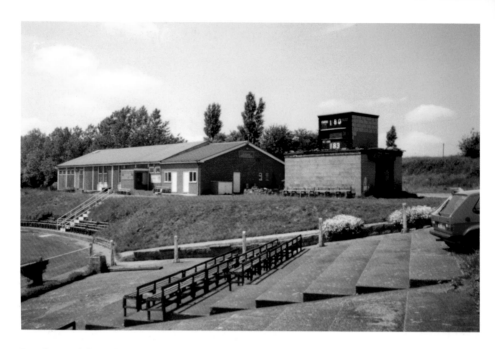

Burslem Cricket Club, Cobridge, 1993 and Tony Toft, 2012

Huge redevelopment between Cobridge and Etruria has also accounted for the removal of Burslem Cricket Club from their old ground in Cobridge Road (above). In the 1930s, the crowd was notorious for barracking opposition players, and it was said that fielding at square leg at Cobridge was 'like being in the lion's den.' The club's new showpiece ground was built with a bowling green attached. Tony Toft is a groundsman with the cricket club.

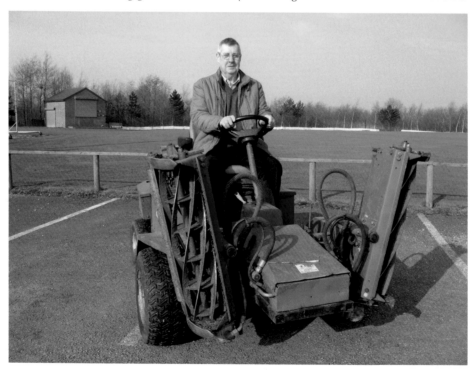

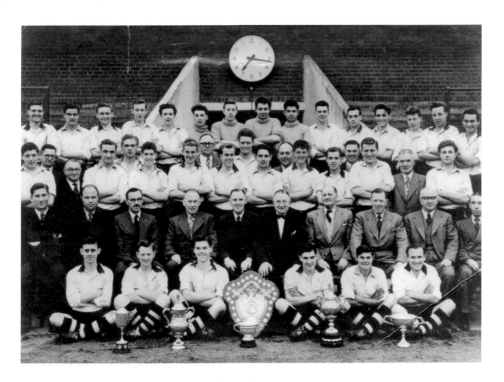

Port Vale Youth Team, c. 1954 and Vale Park, 2012

Vale's youth team is pictured with senior players and officials at Vale Park, in around 1954. On the right of the shield are Ron Mountford and John Reeves. Port Vale moved to their new ground at Hamil Road in 1950. Do you remember the Heavy Metal Holocaust that took place at Vale Park in 1981 to raise funds for the club? Ozzie Osbourne appeared, having recently left Black Sabbath, but the event was headlined by Motorhead and locally-born frontman, Lemmy.

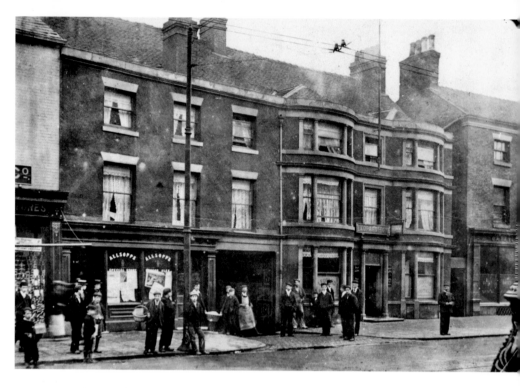

Leopard, Probably 1903 and 1996

Our Burslem pubs tour begins with the town's premier pub. In 1874, decades after the Leopard had been a coaching inn, the Burslem Board of Health debated the subject of stabling accommodation for local horse-drawn traffic at pubs. There was stabling for seventeen horses at the Mason's Arms, twelve at the Red Lion, eight at the New Inn, six at the George Hotel and four at the Duke William – but the Leopard could accommodate fifty!

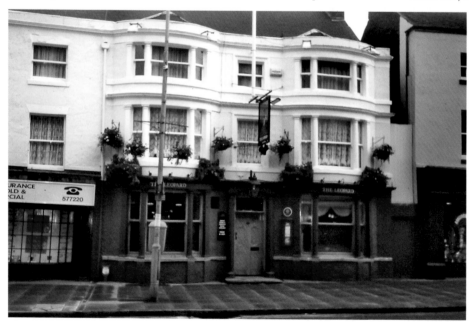

Leopard, 1953 and 2011

This above photograph shows the Golden Wedding celebrations of Robert and Margaret Fowlds, who are in the middle of the centre row. Also pictured are Michael Schonau and Roy Evans, performers with The Squeezebox. Michael has been performing at the Leopard for around seventeen years, and Monday night at the pub is now synonymous with English country and Irish folk music.

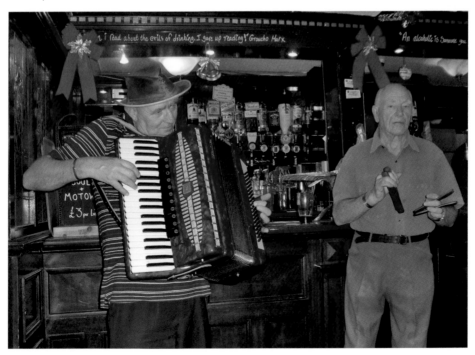

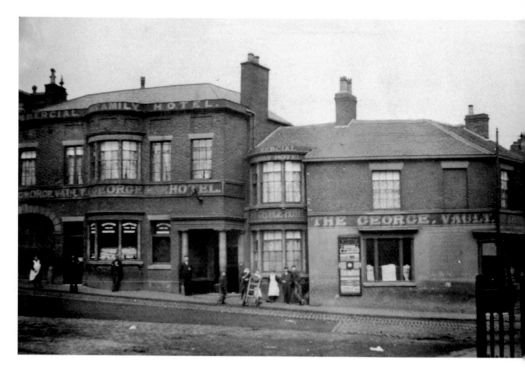

George Hotel, Probably 1903 and 1994

The author Charles Dickens was known to have been an exponent of mesmerism – healing nervous disorders by laying hands on sufferers' heads and bodies. Had you visited the George Hotel in September, 1843, you could have heard 'Lectures on Mesmerism' delivered by Mr Brown, who had already appeared in Hanley. The hotel was rebuilt in 1928/29, but was struggling so much in 1991 that a developer applied for listed building consent to convert it into a residential retirement home!

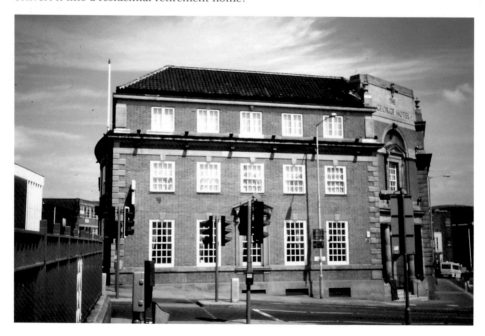

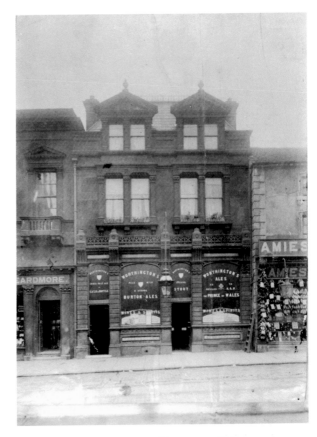

Marquis of Granby Inn, Early Twentieth Century and Saggar Makers Bottom Knocker, 1995 This magnificent pub frontage is no more, for in 1958, mining subsidence necessitated a rebuilding of the premises. The Marquis was rebuilt in two parts, hinged together, allowing the building to move 'in synch' with any future subsidence, whilst staying in one piece. During reconstruction, the builders unearthed pieces of pottery on and around the site. The pub was renamed the Saggar Maker's Bottom Knocker in 1992, and the name shortened to the Saggar Makers in 1996.

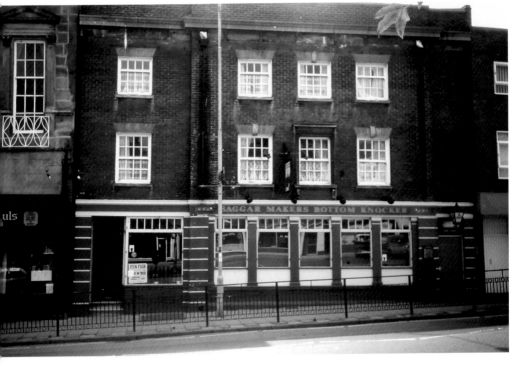

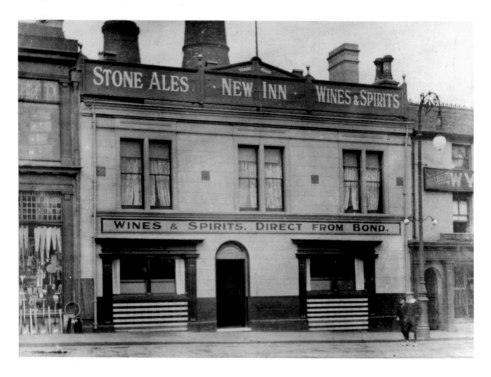

New Inn, Early Twentieth Century and 1994

An early twentieth century plan of the New Inn shows the ground floor incorporating a music room, a hall, a smoke room and vaults. At the back were a private sitting room and a kitchen and pantry. There was a club room upstairs. In 1989, during renovation, a 14-foot deep well was unearthed to the rear of the building. The pub underwent a massive refurbishment in 2005.

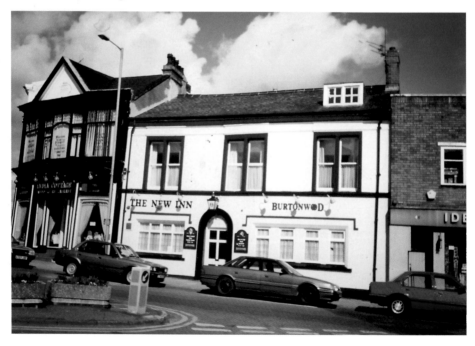

Bull's Head, Probably 1903 and 2009
Nowadays, pub frontages are often
spoiled by strident advertisements
promoting activities such as karaoke,
televised football, meal deals and
more. Our photograph shows that this
St John's Square pub was doing much
the same around 1903. The colour
picture shows Eddie Willatt appearing
as Captain Smith of the *Titanic* and
Mervyn Edwards as Mr Beer. The
Titanic Brewery was founded in
Burslem in 1985 and this pub sells its
ales, which include Captain Smith,
White Star and Wreckage.

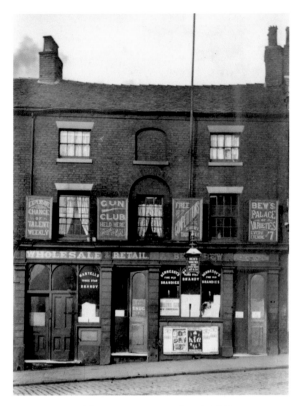

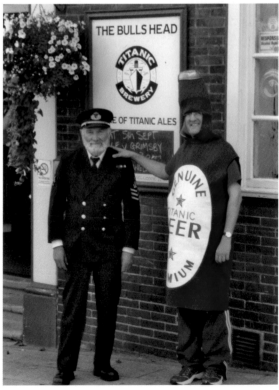

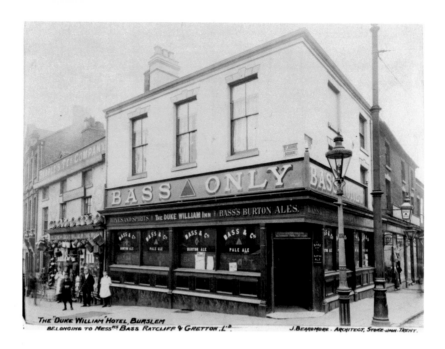

The "DUKE WILLIAM" HOTEL, BURSLEM
BELONGING TO MESSRS BASS RATCLIFF & GRETTON, LD.
J. BEARDMORE · ARCHITECT, STOKE-UPON-TRENT.

Duke William 1903 and 2010

The Duke William in St John's Square looks very different in these photographs, separated by 107 years. Its origins go back some time, for in 1846, sales particulars revealed that this lot, the Duke William Inn, was held under a lease for 999 years, dated 16 October, 1709. The hostelry later staged entertainment. A *Staffordshire Sentinel* press advertisement for 1887 declared, 'Wanted. Everybody to hear the fine talent engaged nightly at the Duke William Music Hall, Burslem.'

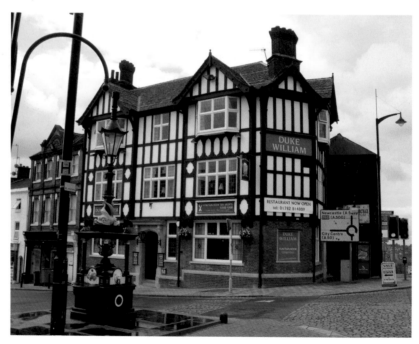

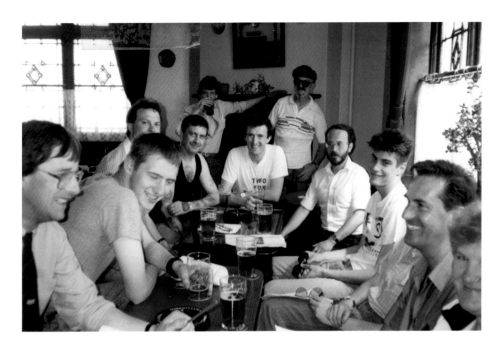

Duke William Bar, 1989 and Lounge, 2010

Our top photograph shows a local history class gathering. From left to right: John Williams, John Heath, Glen Birchell, Keith Rutter, John Lee, Mervyn Edwards, Roy Furber, Andrew Dobraszczyc (tutor), Steve Johnson, David Harper, Thelma Dean. To this day, the Duke William is a splendid place to socialise, as seen in the colour photograph showing Derek Barnard, Phil Glover and Gary Tudor.

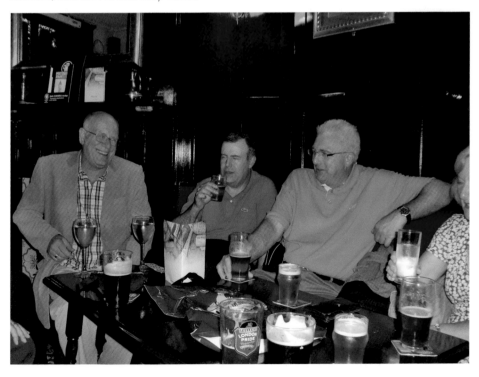

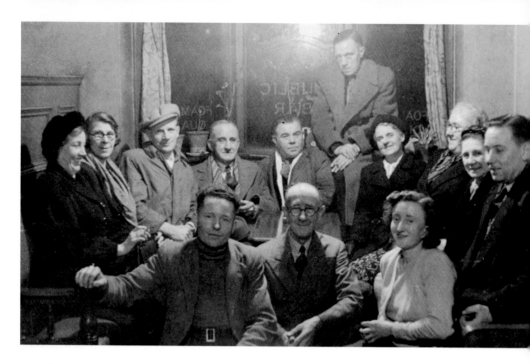

Foaming Quart 1950s and 1989

The interior of the Foaming Quart in Greenhead Street plays host to (from left to right): Emily Seaton, Mrs Walker, -?-, -?-, -?-, -?-, Mary Ann Gater, -?-, Roy Johnson. Bob Seaton is sitting in the window. Front row: Jack Colclough, Billy Simcoe the landlord, Irene Simcoe (Billy's daughter). The bay window arrangement is still evident in the colour photograph, taken in August, 1989.

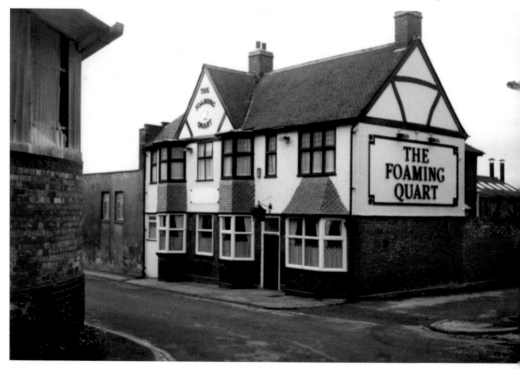

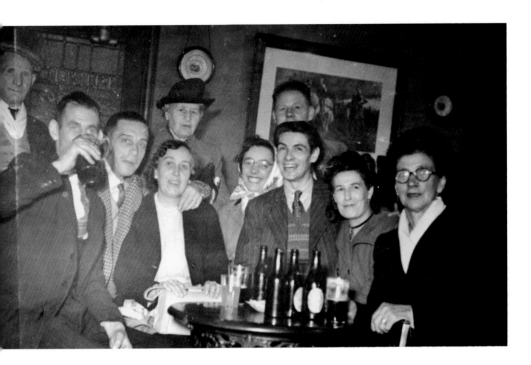

Foaming Quart, 1950s and 2005

Revellers in the public bar. Those known to us are George Wood (second left), Bob Seaton (third left), Emily Seaton (fourth left) and behind her, Mr Cartwright. Harry Williams is third from the right. Bob Seaton senior (1901–1955), a manager at Arthur Wood's potbank, 'waited on' at the Quart, mainly at weekends. The date of the colour photograph is significant, as the Foaming Quart was demolished in May 2005.

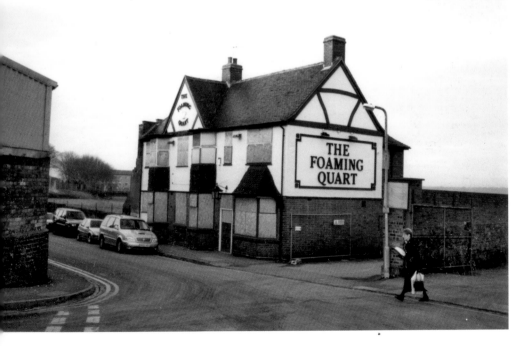

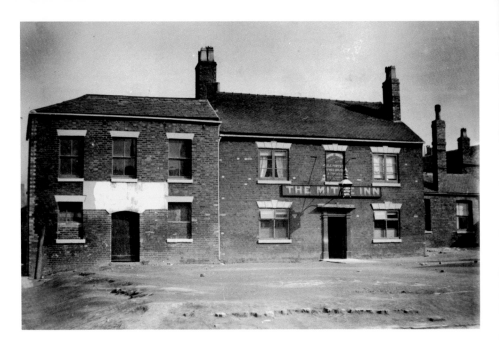

Mitre, Probably 1903 and 2011

The Mitre was a private house before it became licensed premises. In the Burslem rating list of 1802, earthenware manufacturer Thomas Green is listed as the proprietor of property no. 1169 – house and garden, potworks, Commercial Street. This house would later become the Mitre. The house-turned-licensed premises is certainly listed as the Crown and Mitre, Commercial Street, in *White's Directory* (1834). It stands presently as a pub with no beer – and seemingly, no future.

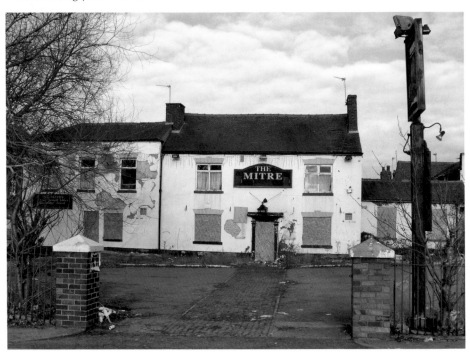

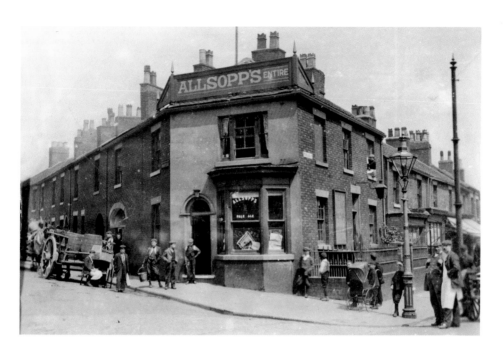

Vine, Early Twentieth Century and 2012

In 1864, Mary Brown encountered Alfred Delves, a local clock and watchmaker, in the Vine. They exited together, 'and went up an entry for an immoral purpose'. Realising that his watch had been taken, Delves 'went after her, but as he has a wooden leg, he fell down, and could not overtake her'. Brown sold the watch for £1, later being committed for trial. The Vine, in Hamil Road, formerly stood nearer to Moorland Road, before its re-building.

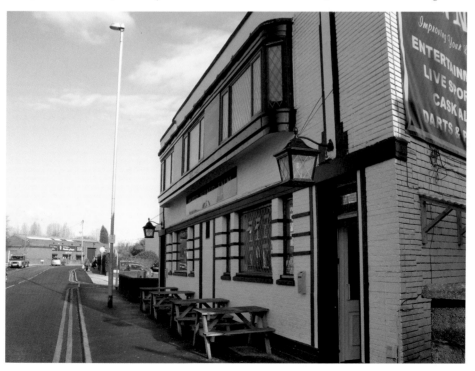

Park Inn, 1989 and 2012

This Park Road pub has in its time been a popular facility for bowlers seeking refreshment after games on the greens at Burslem Park, a stone's throw away. The windows on the Dartmouth Street side of the pub formerly boasted etched depictions of sportsmen and park scenes.

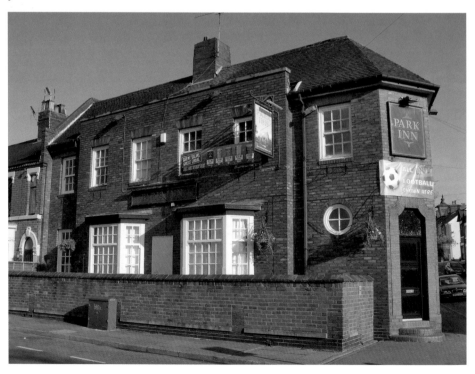

White Hart, 1903 and Huntsman, 1989

Press reports reveal much about the shenanigans that went on in pubs in the nineteenth century. In 1844, Cecil Pope fell asleep in the White Hart, following several drinks. Whilst he was slumbering, another drinker, Joseph Hollinshead, removed his wooden leg and took it to another pub, so that Pope was 'deprived of the means of getting home.' The case was dismissed on the leg being restored. The Huntsman was re-launched as Chillz Bar on 30 September 2011.

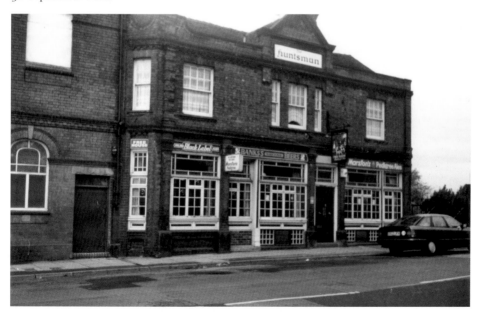

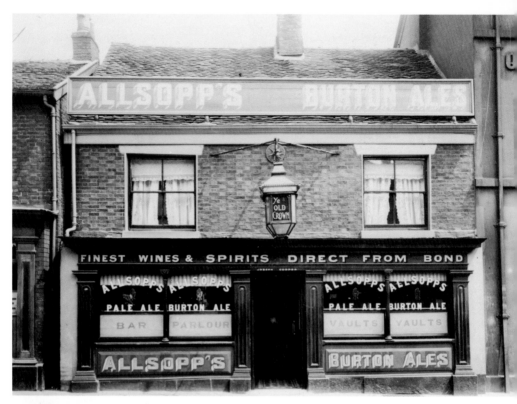

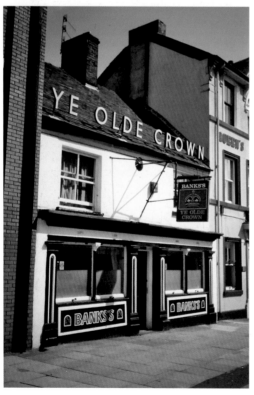

Ye Olde Crown, Probably 1903 and 1994
William Lea was baptised at Keele on
20 May 1759 and died on 13 April 1803.
The Lea family was associated with this
Westport Road pub from 1790 at latest,
and William became the innkeeper. The
Lea connection with the Old Crown ended
around 1870. They were not living at the
pub at the time of the 1871 Census. As the
brewers' tied estates grew, they advertised
their trademarks and their wares more
vigorously on the front of their pubs.
The above photograph is a case in point.
The promoters of the improved public
house, who were very vocal before the
First World War, attempted to stymie such
conspicuous advertising. However, as our
colour photograph shows, history has a
habit of repeating itself. The Crown was
bought by Banks Brewery in 1983, hence
the advertising on its frontage.

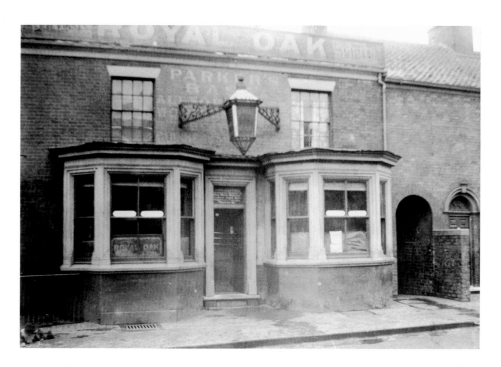

Royal Oak, Probably 1903 and Westport Road, 2012
The Royal Oak is no more, and Ye Olde Crown and the Queen's Chambers building are two of the few buildings remaining that provide a link to this street's past. Much else in Westport Road – formerly Liverpool Road – has changed radically. However, you still hear references to part of this road as the Sytch. The word 'sitch' is chiefly recorded in descriptions of boundaries, and can be dated from as early as AD 969.

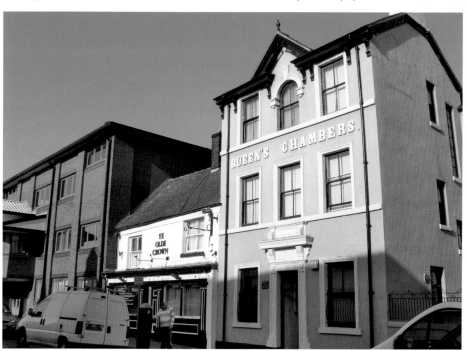

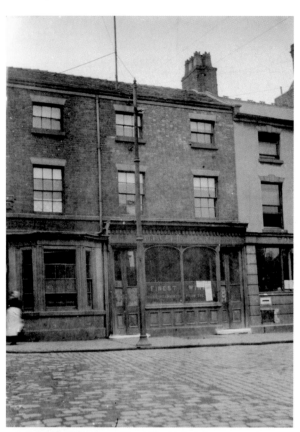

Millstone, Probably 1903 and Lloyds Tavern 1998

The pub is seen in Edwardian times with a neat and tidy frontage. Sadly, nothing lasts forever. The Millstone suffered a name-change in the mid-1980s when it became Lloyd's Tavern. Following a refurbishment it re-opened on 21 November 1997 sporting a bright yellow and green exterior. The owners, the Alehouse Company Limited, were told by Stoke-on-Trent's development control sub-committee to tone down this 'too vivid' colour scheme or face legal action. This objection was raised on account of the fact that buildings within the Burslem town centre conservation area had traditionally been painted in restrained colours. Our colour photograph shows the pub in 1998, shortly after the controversial revised colour scheme.

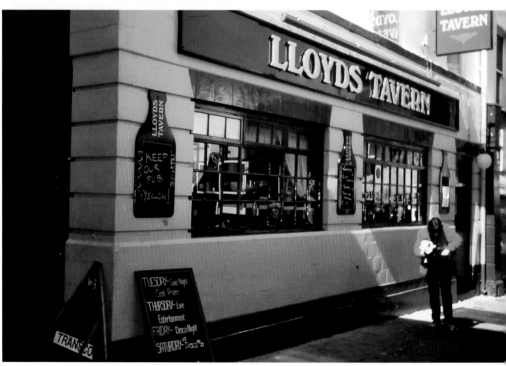

Felons, 1989 and Post Office Vaults, 2006

Our top photograph captures this Market Place pub during the relatively brief time it was known as the Felons. The name referred to the Burslem Association for the Prosecution of Felons, an august body of local citizens who offered rewards for anti-social acts such as trespass and injury to members and their property. The society's formation date is disputed, although we know they were meeting by 1804. The pub reverted to its original name in 1992.

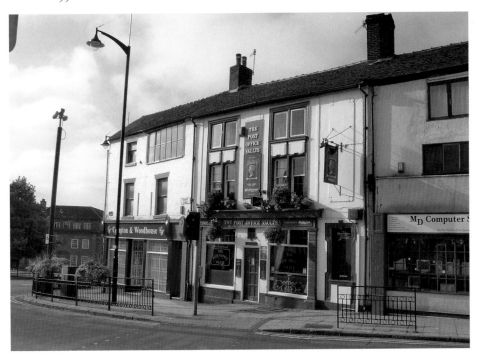

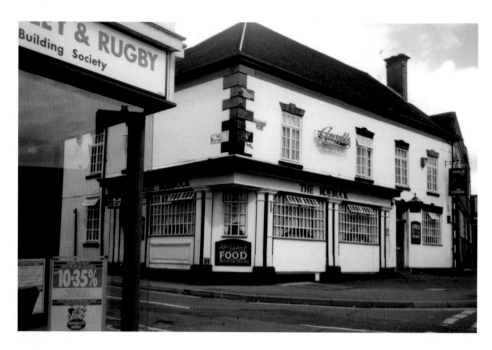

Roebuck, 1989 and 2007

This Wedgwood Place pub appears in the 1818 trade directory. When the Roebuck was advertised as being to let in 1848, it was announced that there was stabling for nine horses as well as a 'spacious warehouse' over the same. In recent years, it has been a popular sports-orientated pub. The white building on the left of both pictures is now the Barewall Art Gallery.

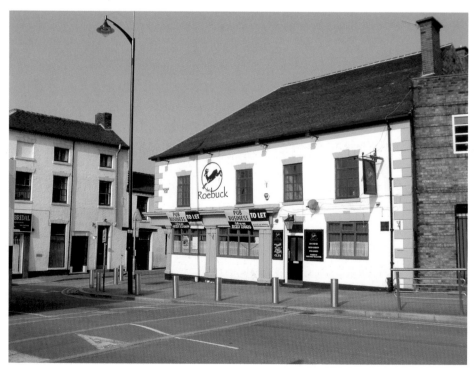

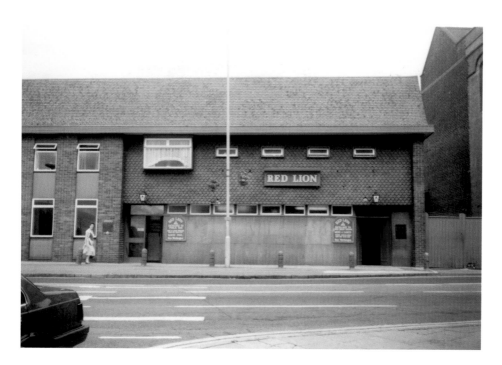

Red Lion, 1989 and 2007

This 1960s rebuilding of an old Burslem pub has changed little over the years, although some of the social activity has had to. A notable incident took place in 1846 when a ring had been formed inside the pub for the purpose of a fight between William Frost and Thomas Eardley. The pugilism was stopped by police superintendent Povey – much to the chagrin of the great number of spectators around the ring.

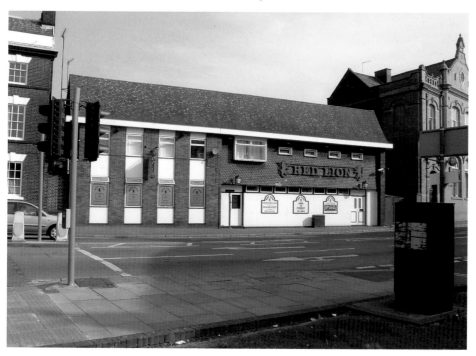

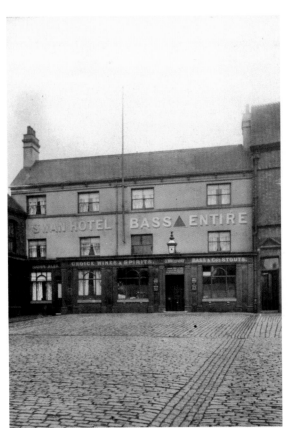

Swan, 1903 and 2004

In the nineteenth century, the Swan enjoyed an association with pottery industry trades unionism. William Evans, trades unionist and founder of the Potters' Joint Stock Emigration Society in 1844, hoped to provide opportunities abroad for a few of the beleaguered potters. For those who contributed to a central fund of money there was the chance to 'escape' to Wisconsin in America, where the Society had purchased land. Unfortunately, only a few departed, and the Society, partly on account of financial difficulties, collapsed – as did the fortunes of Evans. After some time in Wales, he returned to the Potteries, destitute. However, his endeavours had not been forgotten and in 1854 he was presented with a silk purse containing £20, at the Swan. The colour photograph shows Harold Harper, Mervyn Edwards and Ken Smith of the Potteries Pub Preservation Group presenting landlord Syd Lawton with a framed drawing of his pub.

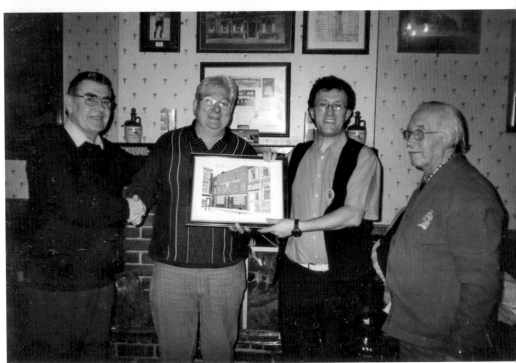

The American Hotel, *c.* 1903 and 1994

This building opened as the Waterloo and American Hotel in 1831 as a hotel, posting-house and travellers' inn. It served the daily coaches to and from London, Liverpool, Manchester and Birmingham that passed along Waterloo Road daily. There was stabling for twelve to fifteen horses. In 1833, it hosted a public dinner to the retiring Burslem Chief Constable Enoch Wood. Wood, who was then seventy-four, said in his speech that he remembered that the spot where they were meeting was formerly distinguished only by 'coal mines and almost trackless paths leading to them.' Never one to hide his light under a bushel, he added that in his youth, 'he well knew every man in the Potteries.' In 2000, the American was re-opened as the American Clubhouse, a centre for people with mental health needs.

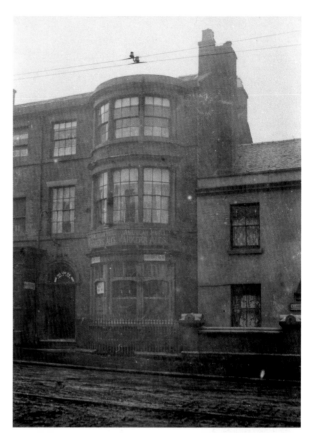

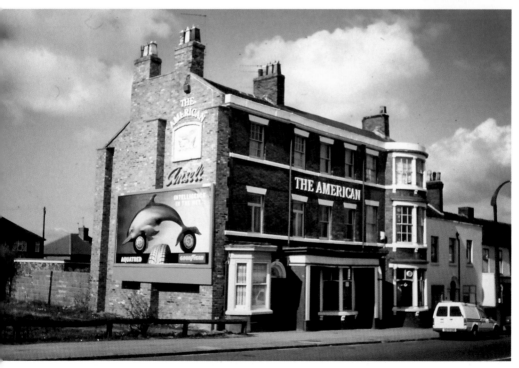

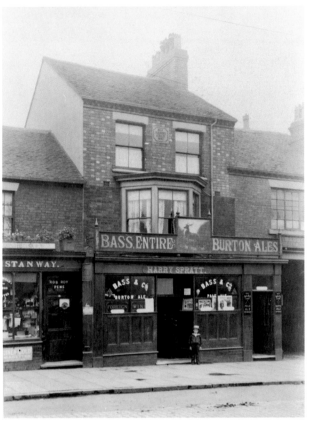

Stag, Cobridge, Probably 1903 and 1989
Visible on the frontage of the sepia photograph is the Bass Red Triangle. It was the first British trademark to be registered (1876) following the Trademarks Registration Act of 1875. The triangle had been used on Bass Pale Ale labels from around 1855. At the time when the colour photograph was taken, there was a small lounge to the rear. The room boasted a dartboard and a piano, and a framed painting of a stag.

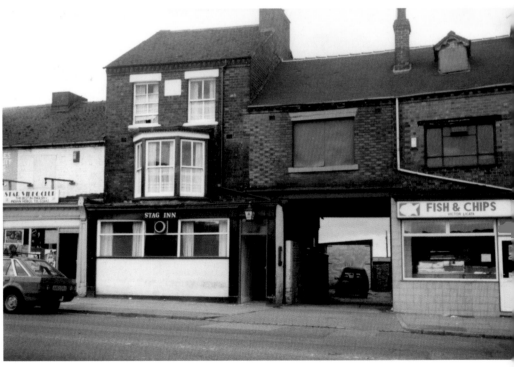

King's Head, Cobridge, 1989 and During Demolition, 1997
The King's Head stood at 260 Cobridge Road and according to CAMRA sources was once owned by Joules of Stone. It was demolished in May, 1997. At the time, the sign attached to the pub depicted the head of Charles II.

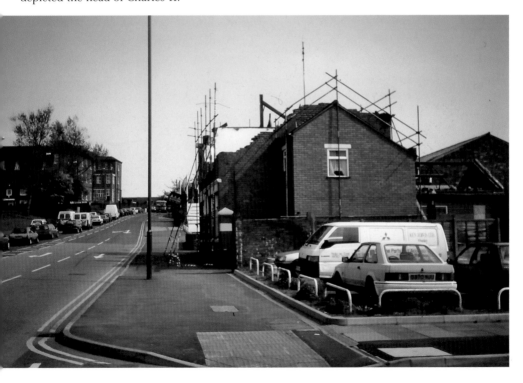

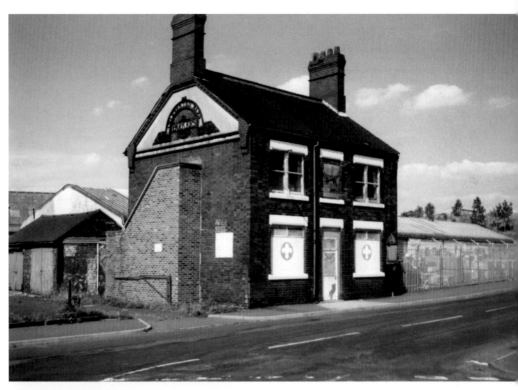

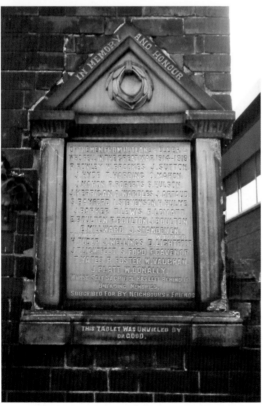

Former Dog and Partridge, Cobridge, in 1989 and its War Memorial, 2002

This former pub is located in Hot Lane, Cobridge – an area mentioned in the parish registers as early as 1702. Several cottages were built here during the eighteenth century with the permission of the lords of the manor. The public house served an industrial community and was in existence by 1782 when it was kept by Thomas Holdcroft. He is described as a collier in the parish registers on 30 March 1784. The pub was situated in the vicinity of Sneyd Colliery. On the front of the building is a war memorial 'in memory and honour of the men from Hot Lane and Elder Road who fell in the Great War, 1914–19... whose self-sacrifice has left behind it unfading memories'. The tablet, listing thirty-six names, was subscribed for by neighbours and friends (and very likely customers of the pub) and eventually unveiled by Dr Good.

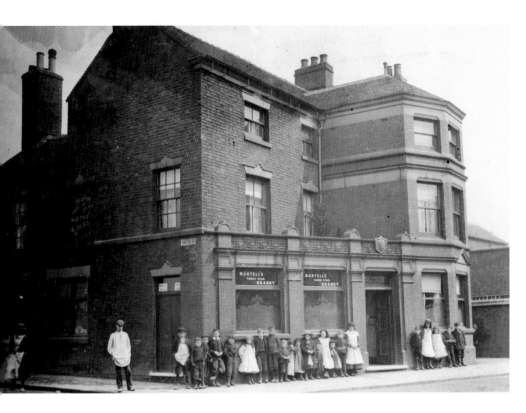

Raven, Cobridge, Probably 1903 and 1995

This pub, on the corner of Elder Road and Sneyd Street, stands in what was the centre of Cobridge in the eighteenth century, before the coming of Waterloo Road heralded a re-distribution of the population. The Raven had a spell as the Pot-o'-Beer between 1988 and 1992.

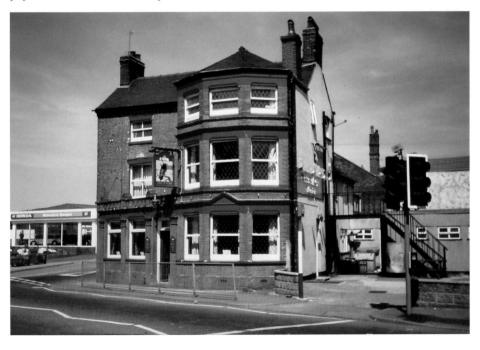

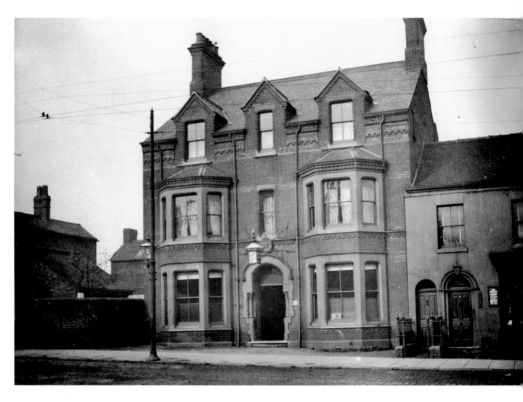

Queen's Hotel, Cobridge, Probably 1903 and 1989
This Waterloo Road pub's bowling green was still being advertised on the building's gable end in 1989. However, its lush turf was used for a rather different sport in 1874 when it played host to a quoits match between the Waterloo Club and Stoke Conservative Club.

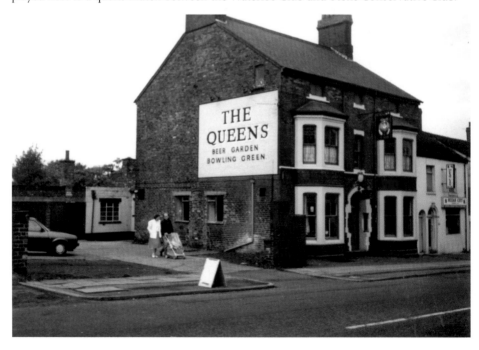

Queen's Hotel Bowling Green, 1991 and Former Hotel, 2011

The bowling green had long fallen into disuse by the time the pub was re-branded and re-named the New Queen, following a £90,000 facelift in 1991. Its new proprietors were LTP Inns Limited. The company named was an amalgam of the first names of the owners – Landon Davies, Tony Brayford and Peter Lister. Ultimately, the pub's fortunes declined and in 2008 the local press announced that it was set to be converted into shop premises.

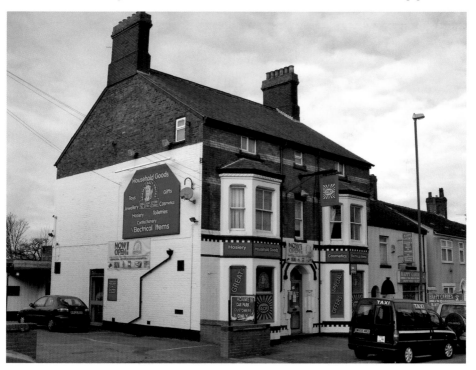

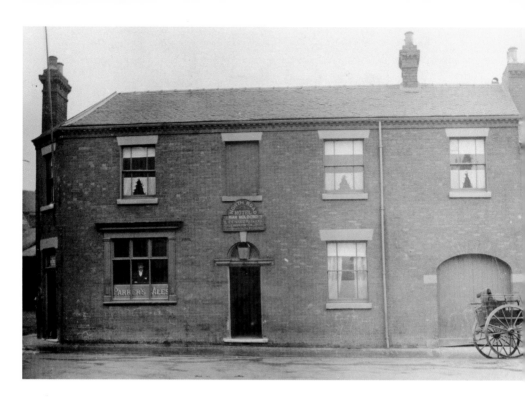

North Road Hotel, Cobridge, Probably 1903 and Re-dedication of War Memorial, 1977
Here's a pub that underwent a name-change in the late 1970s. Its war memorial is dedicated to the men from North Road and district and is placed on the North Road side of the building. It had previously been attached to the nearby Junction pub (formerly the Railway) but moved to the North Road Hotel along with licensee Fred Bennett.

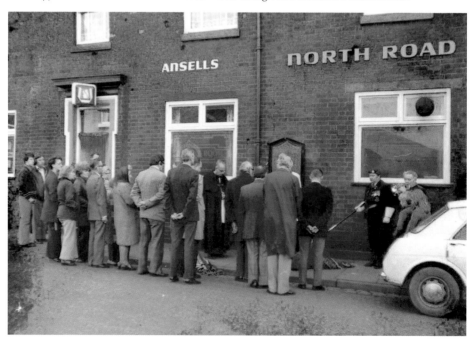

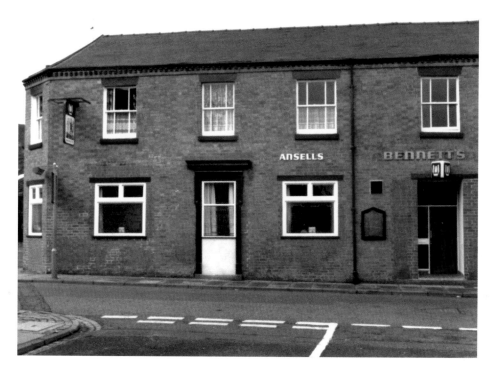

Bennetts, *c.* 1979 and 2011

Fred Bennett's family had lived in the area for generations, and the North Road Hotel was renamed in his honour. Fred had previously ran the Junction with his wife Phyllis, but after she died, he married Trixie Nicholls in 1977.

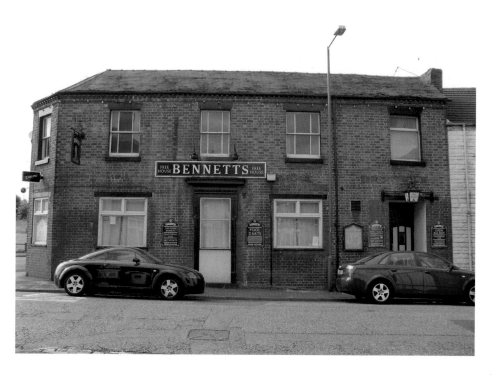

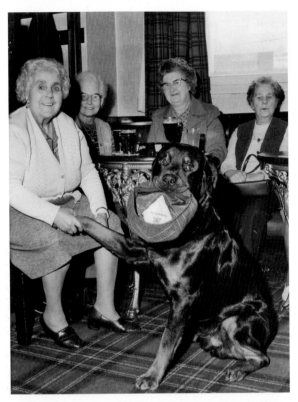

Bennett's, _c._ 1978 and Trixie Bennett, 2012

Trixie, who lives in Smallthorne, recalls: 'We kept a pub dog, a Rottweiler called Kirk. One Sunday lunchtime, the pub footballers were all sitting having a drink when Kirk spotted a customer, Harold Miller, coming in. He jumped up at him, took his cap off and flipped it. The footballers saw this and started throwing money into the hat. Kirk started doing this on a regular basis and we eventually collected about £3,000 for charity.'

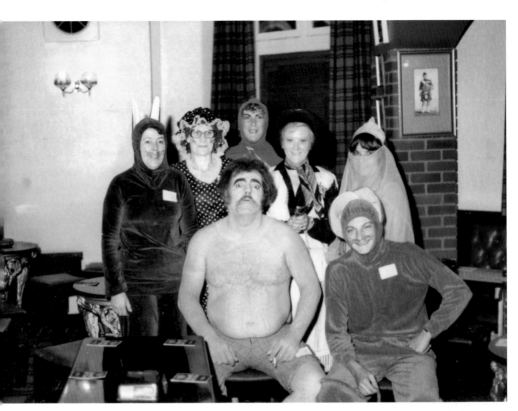

Bennett's Customers, *c.* 1979 and War Memorial, 2011

The customers often raised funds for charity and are seen here in fancy dress. Trixie is the rabbit, whilst one of her customers, Ivan, is the Incredible Hulk. Another, Jonty, is dressed as a mouse on the right. The Bennetts left in the late 1980s. A further restoration of the war memorial was undertaken by licensee Andrew Dudley in 2002, but the pub now stands derelict.

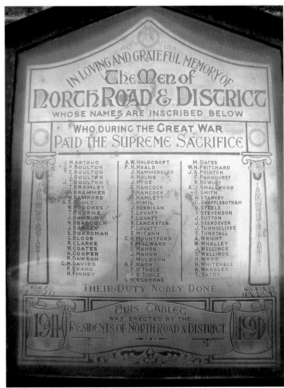

IN LOVING AND GRATEFUL MEMORY OF
The Men of
NORTH ROAD & DISTRICT
WHOSE NAMES ARE INSCRIBED BELOW
WHO DURING THE GREAT WAR
PAID THE SUPREME SACRIFICE

J.W.ARTAUD
P.BOULTON
E.BOULTON
S.BOULTON
J.T.BOULTON
T.BROMLEY
J.A.BRAMMER
W.BAMFORD
A.E.BOULT
W.BROOKES
J.BOURNE
J.BAMBURY
H.BRADDOCK
J.BARKER
E.BOARDMAN
G.BLOOR
R.CLARKE
W.COATES
H.COOPER
R.DAWSON
G.W.DAVIES
F.EVANS
H.FINNEY

A.W.HOLDCROFT
F.H.HEALD
J.HAMMERSLEY
H.HULME
J.HYDE
E.HANCOCK
T.HANCOCK
J.O.HAMLETT
G.HIMIL
J.KERRIGAN
T.LOVATT
F.LOVATT
R.LANCASTER
F.LOVATT
E.McCANN
G.H.MOUNTFORD
E.MILLWARD
O.MAHON
J.MAHON
J.MULDOON
A.F.NASH
F.O'TOOLE
A.O'TOOLE
G.W.OSBORNE

M.OATES
W.H.PRITCHARD
J.A.POINTON
F.PANKHURST
R.ROWLEY
A.J.SMALLWOOD
T.SMITH
H.STARKEY
C.SHUFFLEBOTHAM
D.STEELE
T.STEVENSON
J.SUTTON
J.STANDEVEN
J.TUNNICLIFFE
T.TUNSTALL
A.WRIGHT
W.WHALLEY
S.WELLINGS
S.WELLINGS
H.WOOD
H.WHITEHALL
A.WANDLES
T.YATES

THEIR DUTY NOBLY DONE

THIS TABLET
WAS ERECTED BY THE
RESIDENTS OF NORTH ROAD & DISTRICT

1914 1919

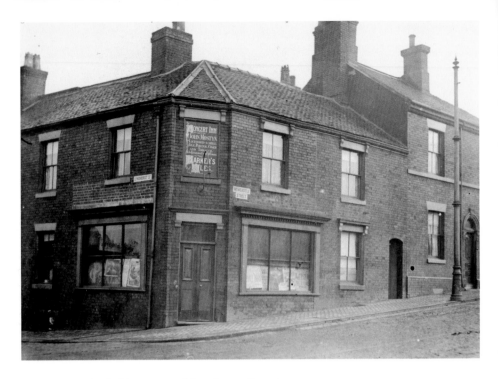

Concert Inn, Probably 1903 and Lyndhurst Street, 2012

The Concert Inn is also listed as the Forresters Arms and stood on the corner of Lyndhurst Street and Newcastle Street. John Mostyn was the licensee at the time when the above photograph was taken, but Sarah A. Mostyn is given as keeping the Forresters Arms beerhouse at 70 Newcastle Street in 1907. A smart little bungalow now stands on site.

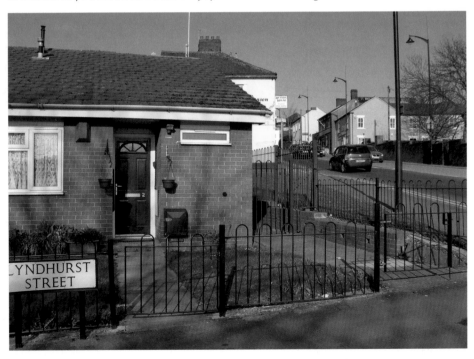

Staff of Life, Dale Hall, 1989 and During Demolition, 1996
The Staff of Life had stood closed for many years until its final demolition in 1996. Its near neighbour, the Great Eastern, was demolished at the same time. This is all a far cry from licensing day in 1839, when it was stated that the Staff of Life was situated in a thriving neighbourhood, near to extensive Longport factories, 'where not less than £2,000 was paid every week in wages'.

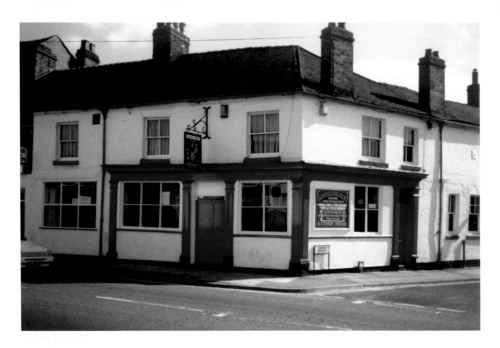

Travellers Rest, Dale Hall, 1989 and 2012

In 2000, Bob Roberts, then in his seventies and a regular patron, regaled the *Sentinel* newspaper with some memories of the pub, which was once used by potters and miners. 'Ragtatters would park their horse and carts in Orme Street. One man complained he couldn't see his horse so some bloke went outside and brought it into the pub so he could keep an eye on it!' Our other photograph shows staff from Burslem's Barewall Art Gallery displaying ceramics.

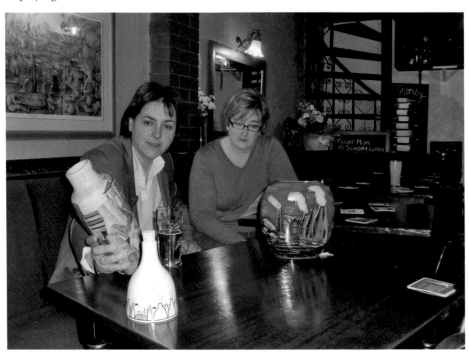

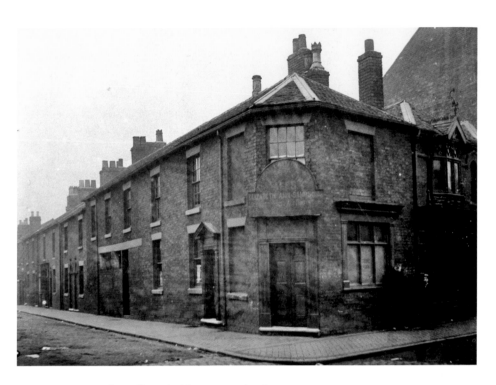

Great Eastern, Dale Hall, Probably 1903 and 1989

There were formerly two pubs in Newcastle Street named after famous ships. Isambard Kingdom Brunel designed the *Great Britain* in 1845, the first large ship to be constructed of iron and to boast a screw propeller. The *Great Eastern* (1858) was an even larger ship. It laid the first transatlantic telegraph cable. Both pubs were demolished.

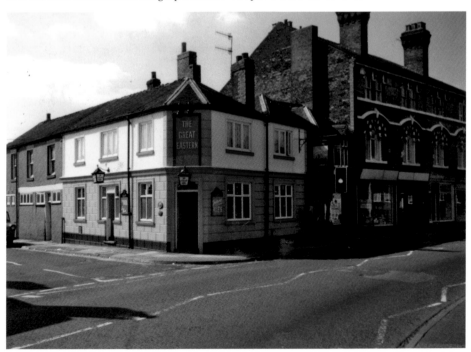

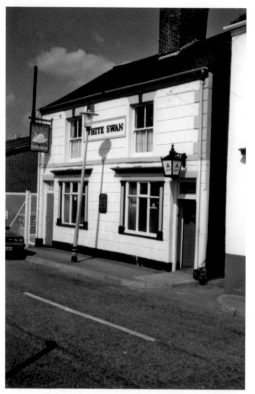

White Swan, Middleport, 1989 and 2002

Tony Moss was a much-loved landlord of the White Swan, running the pub with his wife Jennifer. He was born in 1945 at the long-demolished Dolphin in Greenhead Street. He was known as a character, almost the last of a dying breed of pub landlords. The toasting fork he is holding measured 6 feet 3 inches from end to end and was made for him by a customer, John Kelsall. It enabled him to sit back from the heat of his coal fire, whilst making toast for customers. He once ordered a plastic gazebo from the *Mirror* newspaper, and erected it in his public bar, calling it 'the only inside beer garden in Stoke'. A CAMRA-organised 'shot-putting' competition took place outside the White Swan in 2005 with contestants having to hurl an odd-shaped parcel as far as possible. The winner received the contents of the parcel: two cans of corned beef and a tin of Spam, all rather dented!

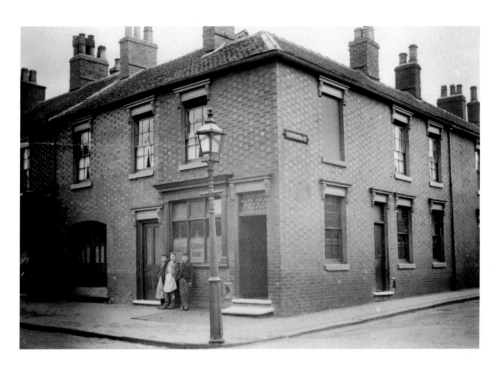

Crewe Arms, Middleport, Probably 1903 and Meole Terrace, 2011
The Crewe Arms stood in Wharf Street, Middleport, and was kept in 1907 by W. Oseland. He was evidently public-spirited, as he donated a seat to Middleport Park, which opened in 1909. The pub is long-demolished, and so is most of Middleport – hence the protesting graffiti on the front of this row of housing, Meole Terrace, built in 1895. The words read: 'The Big Society. Not in SOT, evidently'. The terrace was demolished shortly afterwards.

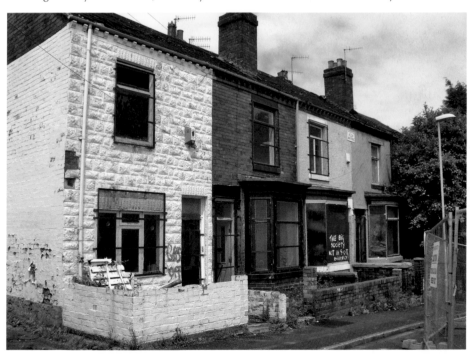

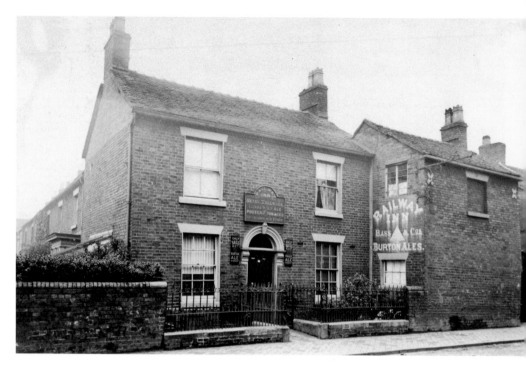

Railway Inn, Longport, Probably 1903 and 1995
The notice on the front of the older photograph tells us that the publican, Henry Thelwell, was licensed to sell ale, porter and tobacco. A 1907 trade directory lists Ann Thelwell as the proprietress of the Railway Inn at 54 Station Street. The pub was still trading comfortably by 1995 but at the time of writing (March, 2012) has stood derelict for several years.

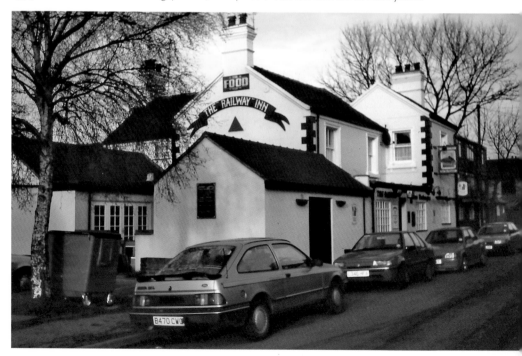

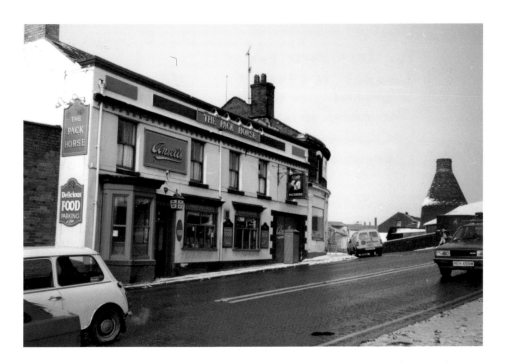

Packhorse, Longport in 1991 and 1997

Hugh Henshall was an influential man in Longport. Not only did he supervise the completion of the Trent & Mersey Canal after James Brindley's death in 1772, but he managed the main wharf at Longport for the Trent & Mersey Canal Company. Around 1780, he built the Packhorse Inn, which offered accommodation for boatmen and their horses. By 1871, it incorporated a large billiard room, whilst outbuilding embraced piggeries and a skittle alley.

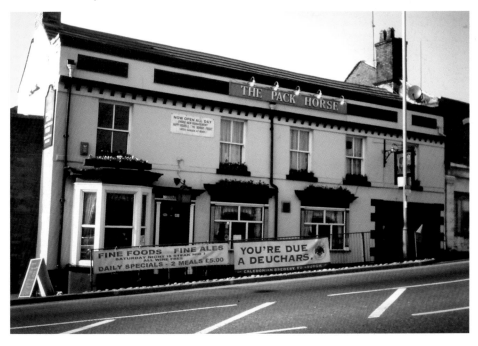

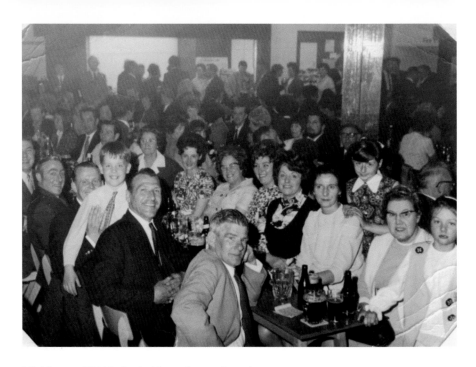

Middleport WMC, Probably 1960s and 1996

Middleport WMC was a proud old club opened in 1919. Former club members recall being well-looked after, remembering free drinks at Christmas, outings for children and various sports. There was even a fishing club attached. Middleport WMC also had a crown green bowls team that played in the Club and Institute League at Middleport Park. Over the years, its players included Stan Martin, Albert Mellor, Harold Higgins, Les Jones and Peter Kerry.

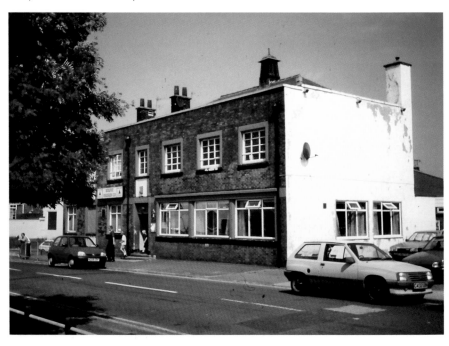

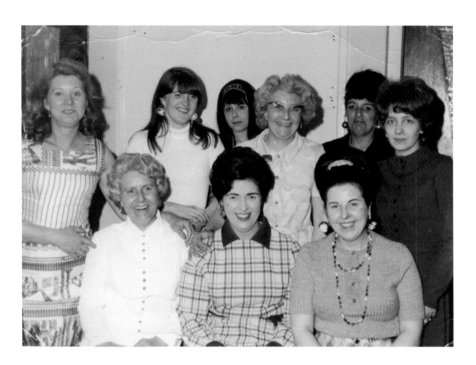

Middleport WMC Ladies, 1969 and Derelict Middleport WMC, 2010
Lady members from Middleport WMC are seen at the Queen's Hall, Burslem in 1969. The Reg Bassett Orchestra provided music for the occasion, which was an annual prize-giving dinner dance. That year, the club celebrated its golden anniversary. Stan Martin was Secretary and Norman Findler was President at the time. Women were not accepted as members until 1927. However, they were not permitted in the gentlemen's bar and were expected to sit in their own room, known as the snug.

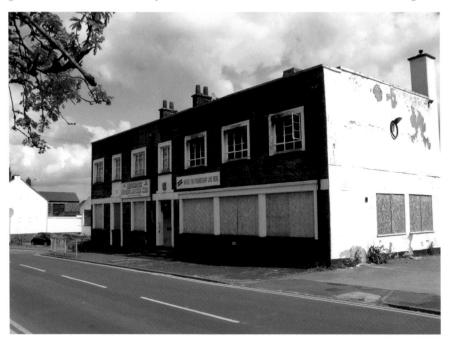

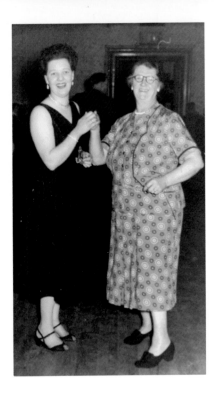

Mrs Okonski from Middleport WMC, 1969
Mrs Doreen Okonski and Mrs Dayson enjoy a dance
at the celebration of the club's centenary held at the
Queen's Hall in Burslem.

Acknowledgements

Barewall Art Gallery, Trixie Bennett, Sheila Bonehill, Alan Brookes, Sheila Carter, Clifford
Dabs, John Draycott, Irene Falkingham, Pat Foster, Elizabeth Fowlds, Mary Frost, Dorothy
Grocott, Harold Harper, Derek Hayes, Darren Knowles, Frank Leigh, Margaret Montgomery,
Ron Mountford, Peter Okonski, Elsie Rhodes, Ann Savage, Bob Seaton, Paul Seaton and
Woolworths PLC, *Sentinel* newspaper, Gary Tudor, Desmond Wilson, Jean Wood.